THEN & NOW

BUCKEYE

OPPOSITE: Kell Store, the oldest building still standing in Buckeye, is near Sixth Street and Centre Avenue. Built in 1890 by Joe Irvine and Grant McWilliams, it was a saloon from 1890 to 1897. By 1999, Ed Kell, Cora Clanton Kell's husband, had opened a store and relocated the post office to the former saloon building. When the railroad arrived in 1910, the Kells moved their store to the Ware Building on Fourth Street and Monroe Avenue. Kelly Carmony purchased the old saloon/store in 1947, and the South Side Grocery Store existed there for approximately 10 years. It is now a place of residence.(Then image courtesy of Buckeye Valley Museum.)

THEN & NOW

BUCKEYE

Verlyne Meck

To Tom Oviatt,
Remember Then — Cherish Now!!
Class of 1961yea!

Verlyne (Henry) Meck
May 7, 2011

To my husband and best friend, Jackie A. Meck, my deep appreciation for your encouragement and support for this book. Remember: "I'll Walk Beside You."

ON THE FRONT COVER: These views of Buckeye's business district are Monroe Avenue (U.S. Highway 80), pictured here around 1920. Looking west from Fourth Street shows a busy downtown scene. The current drugstore location has remained a drugstore since its beginning. From 1921 to 1923, concrete paving from Phoenix was completed, and U.S. Highway 80 became a cross-country route through Buckeye. The 2009 scene includes Buckeye's first traffic light, installed at Fourth Street and Monroe Avenue around 1971. (Then image courtesy of Buckeye Valley Museum; now image courtesy of Tito Suazo.)

ON THE BACK COVER: The Ware Building was constructed in 1910 at the southwest corner of Fourth Street and Monroe Avenue. The building had a decorative brick cornice and windows with fabric awnings above the storefront windows. The Buckeye Valley Bank occupied the angled corner in 1911. By 1912, the Buckeye Restaurant, the Buckeye Valley Market, a barbershop, and *Buckeye Valley News* were tenants. Monroe Avenue became the main street when the name "Buckeye" was officially adopted by the town of Sydney in 1910. During 2008 and 2009, a new owner, Jean Faraj, restored the building. (Then image courtesy of Buckeye Valley Museum.)

CONTENTS

PIONEERS

Pioneers lived the simple life,
Doing good to others;
Helping those who were in need,
Being Dads and Mothers.

They never knew the comforts
That many know today;
But they practiced Godly living,
For they knew how to pray.

They were always good at sharing
What little came their way;
And their ears were always open
To what others had to say.

Their work was hard, the hours were long
From dawn to setting sun,
But they took time to socialize
And have a little fun.

They lived not merely for today,
Their eyes were on tomorrow,
That those who followed in their steps
Might have less grief and sorrow.

We salute you, Pioneers,
We're thankful just for you,
For through your love and sacrifice
You've helped our dreams come true.

—Delbert S. Wood (1901–1998)

ACKNOWLEDGMENTS

Everything that is done involves the help of others, and this project is no exception. I have come to understand more and more the value of stories and photographs from our past. A collection such as the one in this book shows our heritage, and from such a collection we can learn who we are and develop a sense of place. Home is where the story begins.

I am grateful for those who preserved the Buckeye Valley history by writing it down. Having their thoughts and recollections were invaluable to this project. My everlasting appreciation to I. H. Parkman, Park Mitten, Edith Mae Christian, Bill Kaufman, Eliza Narramore, Delbert and Neva Wood, Velma Benbow, John Beloat, Ella Murphy, Herman Schweikart, Wanda Narramore, Lee Hunter, Lola Johnson, Steven Bales, Noal Hamilton, Annette Napolitano, Borden Kirk, Jackie Meck Jr., June Dean, Don Balmes, W. Bruce Heiden, Vera Holloway, and Martha Gayle.

To the photographers and keepers of photographs, words cannot express my gratitude for the sharing of your treasures. A special acknowledgment goes to photographers Lew Wharff and A. J. Ross for their recording of days past. A present-day photographer, Tito Suazo, continues the preservation of history through photography. Karen (Williams) Goins, a Buckeye native, and Jared Jackson from Arcadia Publishing were always there with word processing and scanning skills, making the book a reality. As I say, it is not what I know but whom I know. I appreciate you both so much.

To my text reader James Grosbach, you were awesome! Thank you, thank you, and thank you for your editing expertise. To Linda (Sanders) Hardison and Linda (Armstrong) Davis, your special assistance was invaluable. Thank you. A special thank-you goes to Lee (Buddy) Faver for his memory in recalling stories. I will miss asking him for the real story.

Lastly, I want to acknowledge the Buckeye Valley Museum staff: Chris Larson, Janna Brunson, and Pat Langford as they "Brought the Past to Life by Preserving our Local History." Thank you for your dedication.

—Verlyne (Henry) Meck

Unless otherwise noted, all images are from the author's personal collection.

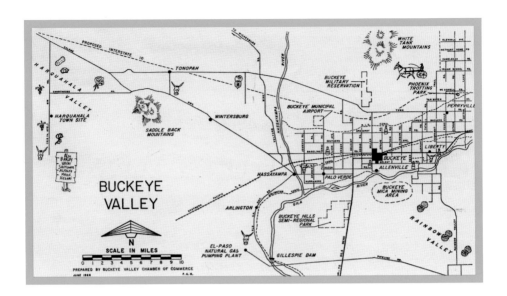

BUCKEYE
VALLEY

N

SCALE IN MILES

0 1 2 3 4 5 6 7 8 9 10

PREPARED BY BUCKEYE VALLEY CHAMBER OF COMMERCE
JUNE 1966 F.G.B.

INTRODUCTION

Maricopa County in the Territory of Arizona was created in 1871, and during the late 1870s and 1880s, the Salt River Valley began its agricultural boom. The search for new agricultural lands extended beyond the Salt River. In May 1885, Malie Monroe Jackson and Joshua Spain located "an irrigation ditch near the mouth of the Aqua Fria River at its junction with the Gila River." By September, the Buckeye Canal Company, so-called in honor of Jackson's home state of Ohio, had filed its articles of incorporation with the territorial secretary. By 1886, of that same year, water was turned into the canal and the historic settlement of the Buckeye Valley truly began. Within a few years of the completion of the canal, 16,000 acres of farmland began to be developed.

The crop that supported this first generation of Buckeye Valley farmers was alfalfa. Alfalfa was a great crop for the valley because it could be stored for long periods and required little water. This was important, as the valley was isolated. The market for alfalfa seed was strong. Alfalfa was a crop that gave local farmers and beekeepers several ways to make money. First from the honey produced by the bees, second from the bee-pollinated alfalfa seed, third from the alfalfa plant as livestock feed, fourth as grazing areas for sheep, and fifth from the wool grown on the sheep. It is no wonder that the Buckeye Valley became known as a prime agricultural area.

The attraction of new lands for farming drew settlers to the valley. By 1890, there were thriving communities at Liberty, Palo Verde, and Sidney (later to be called Buckeye). A decade later, in 1899, the development of the Arlington Canal to the west resulted in another vital and growing community called Arlington. Adjoining valley areas that became inhabited were Harquahala Valley to the northwest and Rainbow Valley to the southeast of the Buckeye Valley.

Liberty, Palo Verde, and Arlington were loose collections of farms and ranches connected by common schools, a post office, stores, and churches. Activities associated with schools and churches brought the local people together for work and socializing. The local general stores and post offices also served as informal gathering places. The post office named Buckeye was established on March 10, 1888. Established post office dates for surrounding areas were Liberty in 1901, Arlington around 1907, and Palo Verde in 1910.

Sidney (later Buckeye) became a true town when two men, Thomas Newton Clanton and Oscar L. Mahoney, subdivided 1 square mile (640 acres) of land in September 1888 at the center of the Buckeye Canal with the intention of selling lots. They named the town Sidney. Why that name was chosen is unclear to this day. All other homesteaded lands in the area were used as farms and ranches. Sidney was the only place under the canal where an individual did not have to own a farm or ranch to own land. This presented the opportunity for shopkeepers and other trades people to start businesses to serve the valley and limit travel to Phoenix to obtain supplies.

As long as there was land available for farm development under the canal, the valley grew at a steady pace. That population growth, however, slowed as the land was taken up. The pioneer period of the Buckeye Valley had come to an end as new farms tapered off. A few rough wagon roads were all that connected the Buckeye Valley to the outside world. A trip to Phoenix took several days.

In 1910, the valley took a big step toward improving its connection to the outside world in its hope to spark renewed growth. On July 25, 1910, the railroad came to the area. Suddenly Phoenix was much closer.

Sidney especially saw bright things coming with the train. To take advantage of the expected spurt in business, the plat of the town site was redone. The original main street (Centre Street) was relegated to secondary status. Monroe Avenue became the new main street. Fourth Street and Monroe Avenue became the new center point of Buckeye, and Fourth Street would now lead to the railroad station. Modern new buildings were constructed. The town even changed its name from Sidney to Buckeye. When the railroad age arrived, it joined another new form of transportation, the automobile, which had come in 1907. The automobile became common, and one of the first paved transcontinental highways (U.S. Highway 80) was built through the Buckeye Valley in the early 1920s. In 1922, the surrounding farming communities were suddenly seeing visitors in numbers no one would have anticipated a few years earlier. New businesses such as garages, hotels, and restaurants were started to address the needs of travelers.

In 1927, a new canal, the Roosevelt Canal, was built across the valley. This canal, spearheaded by S. Carl Miller, took excess water from the Salt River Project and brought it to undeveloped desert land north of the Buckeye Canal. When completed, about 34,000 new acres would be available for farming. Miller also planned a new town, Valencia, an upscale community with Spanish colonial–style architecture. He located his new town at the center of the Roosevelt system just north of Buckeye and the railroad track.

By the late 1920s, cotton was rapidly replacing alfalfa as the money crop. A huge new demand for cotton was created as tires for automobiles were made with cotton belting. Growing and harvesting cotton required different technology and labor needs. At that time, cotton had to be chopped by hoe and picked by hand. This meant many people had to be hired.

In 1929, the nation entered into the Great Depression, and Carl Miller's dreams for the model community of Valencia ended. The greater project, the Roosevelt Irrigation District, was completed and a new economy, cotton, changed the Buckeye Valley. As the Depression grew across the United States, many unemployed people moved west. Many ended up in Buckeye Valley, where cotton provided employment. New businesses, new buildings, new subdivisions, and new people were appearing all over the place. Buckeye, incorporated in 1929, had become a thriving small town.

Both agriculture and highway-oriented businesses experienced major changes in the 1950s and 1960s. The increasing mechanization of farm work greatly reduced the number of farm workers needed. By the late 1970s, the new Interstate 10 and Interstate 8 provided high-speed routes across the United States, and Buckeye's economy was affected. Now the Buckeye Valley entered another growth period. Traveling to Phoenix became faster, and new housing developments sprouted. This time the cash crop became people rather than cotton, alfalfa, or dairies. By the 2000s, Maricopa County's new edge of development was the Buckeye Valley. Sundance and Verrado were the first of many new housing areas that began to mark a new era. In 2009, the farming town had become a thriving urban area of 650 square miles with an estimated population of 45,000. It is Arizona's largest small town.

—Michael Sullivan, condensed by Verlyne (Henry) Meck, 2009

SCENES AROUND THE VALLEY

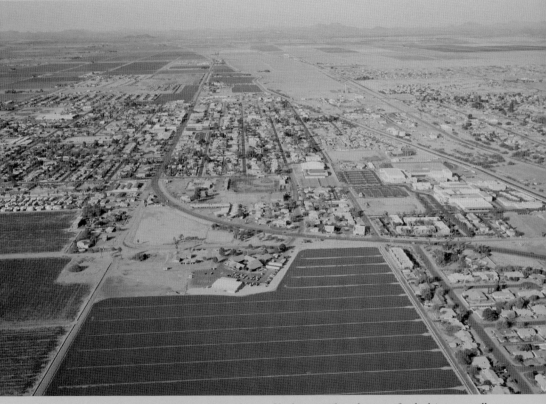

Still visible are parts of U.S. Highway 80 on the east entrance to Buckeye next to the Buckeye Canal. The highway came straight from Phoenix and turned south to where Hobo Joe is now located. According to a February 12, 1912, *Buckeye Valley News* article, "The state and national highway has been laid out through Buckeye. The state is spending money rapidly to complete its systems of highways. When these are finished Arizona will become the winter playground of the automobile. All of them that come from the coast or go through to it will go through the Buckeye Valley. Buckeye at one time was out of the way but it is certainly on the way now." (Then image courtesy of Tito Suazo.)

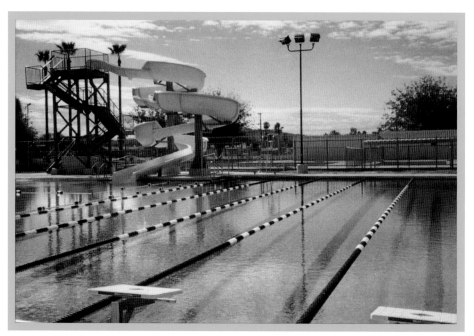

Pictured below around 1928, the neighbor kids swam to keep cool near the Conley home in Liberty. The Buckeye Aquatic Center in 1998 (shown above) gave an upgrade to swimming opportunities. The pool played host to the Buckeye Union High School (BUHS) swim team. One fine swimmer, Lara Benbow, is a member of the Conley, Couch, and Benbow lineage. (Then image courtesy of the Velma Couch Benbow Collection.)

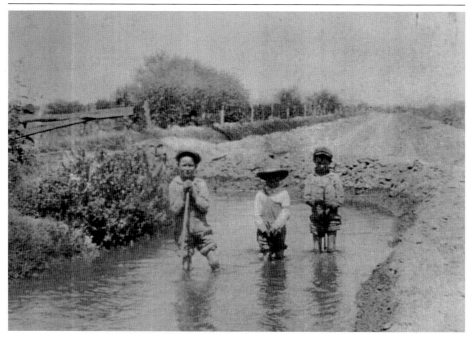

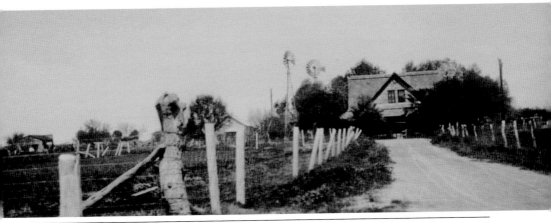

Peder Benson, one of the Benson brothers, built his home in Palo Verde around 1890 (pictured above). His brother Nels built his home in Buckeye on Beloat Road, and it was moved in 2006 to a new location south of Buckeye. The new owners have plans for it to become a brewery. Peder's home in Palo Verde is now remodeled and occupied by the Randy Lanford family (shown below). (Then image courtesy of Buckeye Valley Museum.)

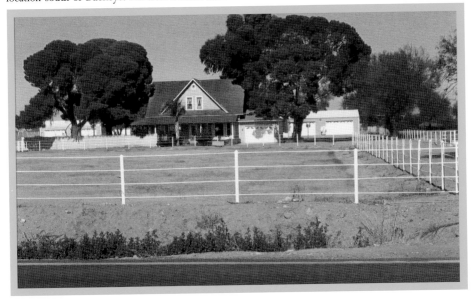

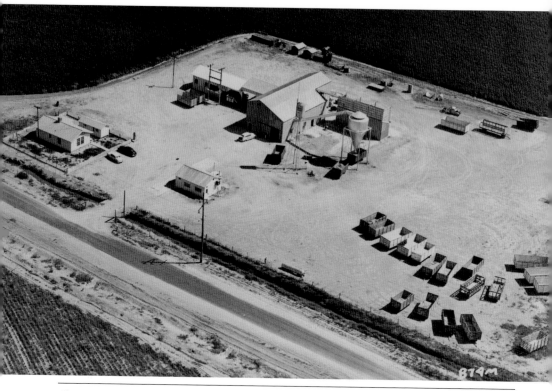

Changing scenes of agriculture are now the norm. The above image shows a 1955 bird's-eye view of the Anderson Clayton Valencia Gin, while the photograph below, taken in 2009, shows fields of Shea homes, alfalfa, and cotton bales. This gin, on Southern Avenue west of Miller Road, stands as a silent sentinel to changing times. It is currently one of three working gins in Maricopa County. (Then image courtesy of Tito Suazo.)

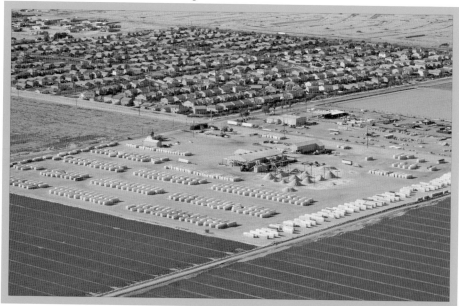

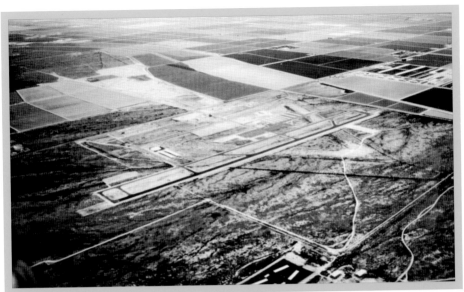

An airport for Buckeye began in 1946 with the Saguaro Air Park, owned by Pat Brabbin and John Yanik Flying Service. It was located 1 mile southeast of Buckeye. Due to many trees and alkali soil, the airport was relocated 3 miles north of town. In 1948, the airport was owned by Wade Loudermilk, and from 1951 until 1959 Sherman Moore was the owner. Moore sold to Pierce Aviation, and the airport was moved to the L. G. Stephens property west of Miller Road and north of Highway 85. In 1968, Pierce Aviation relocated the airport to its present site at the crossroad of Highway 85 and Oglesby Road. The present Buckeye Airport is located at 3000 South Palo Verde Road. A side note: That location, in 1942, was Field No. 5 for Luke Air Force Base, as it utilized crosswind training. (Then image courtesy of Boyd Richardson.)

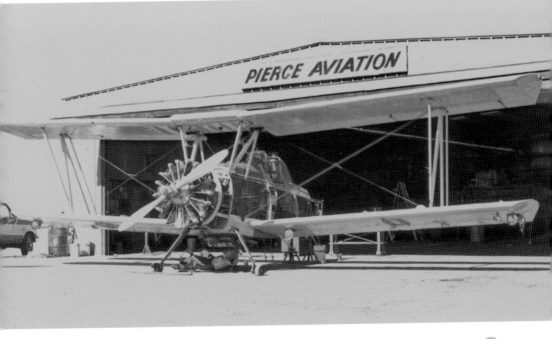

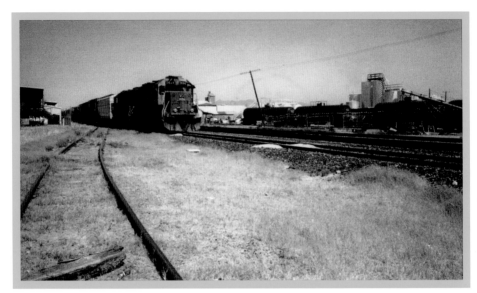

Here comes the train to Buckeye from Phoenix on July 25, 1910. A steam locomotive brought 43 passengers on the first trip to Buckeye for $1.95 each. The train track only extended to the Hassayampa River and ended in a Y, so the train could head back to Buckeye. The train was sold for scrap metal during World War II, and a stove at the Buckeye Museum is either from the train or the train depot. The depot was located east of Fourth Street and was torn down in the late 1960s. George Hunter remembers watching the train while playing on a concrete ramp with his bicycle, and, without stopping, the train would pick up the daily mailbag. (Then image courtesy of Buckeye Valley Museum.)

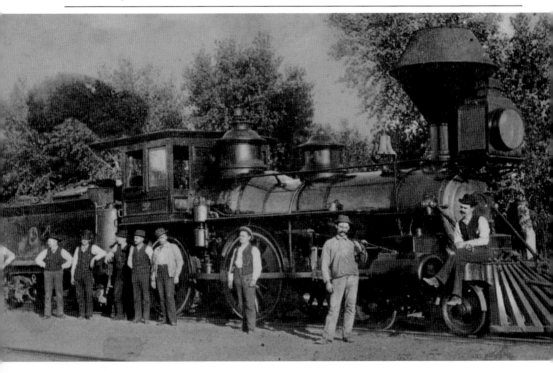

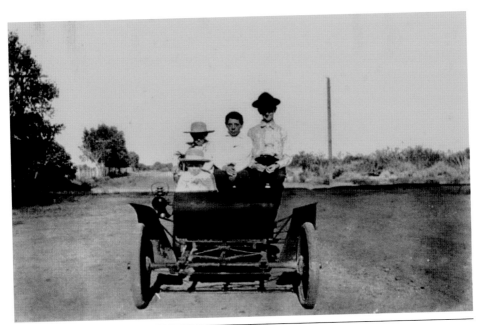

A new mode of transportation arrived in Buckeye on Christmas Day in 1907 when the first doctor, Dr. Laurence Thayer, bought the first motorcar, a Buick. For many years, the car was stored in Dr. Thayer's garage at his medical office at Third Street and Monroe Avenue. Roy Dean Sr. purchased the car from the Ames family, who had bought it from the Thayers. Dean said the car was painted blue and gold in 1940 and was driven on the Buckeye Union High School football field at homecoming. According to Roy Dean Jr., the car still displays some gold paint. Pictured above are family members of the Kells and Hadsells. In 1908, there were three automobiles in Buckeye. (Then image courtesy of Buckeye Valley Museum.)

SCENES AROUND THE VALLEY

Kell Park, on North Sixth Street, was donated in memory of Herbert E. and Cora J. (Clanton) Kell. The Buckeye Public Library was built and dedicated in 1971. The library was a result of community cooperation through Pioneer Days. Librarians through the years were Lucy Sly in 1940, Doris Huff from 1952 to 1957, Dessie Miller from 1958 to 1972, Dorothy Huntsman from 1972 to 1979, Billie Piercy from 1979 to 1984, Kay Blanton from 1984 to 1992, Jeanine Guy from 1992 to 2003, Cheryl Sedig from 2003 to 2007, Sarah Blank from 2007 to 2009, and Chris Larson as of 2010. Friends of the Library members have created a present-day setting where the spirit of community service thrives. On September 3, 2008, a bookmobile was unveiled at Bayless Park, and it serves Buckeye, as shown below in Verrado.

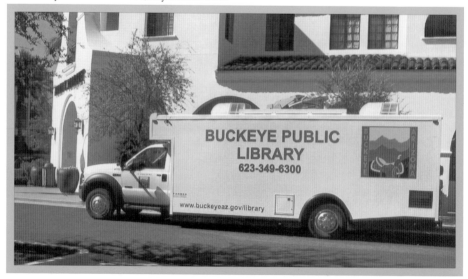

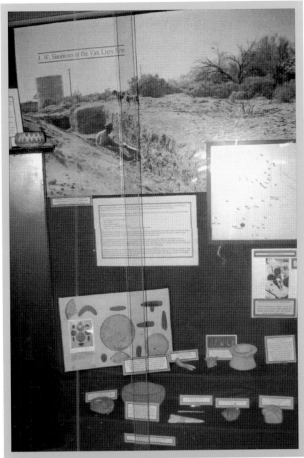

Shown below in 1954, Buckeye youngsters climbed Robbins Butte, also known as Palo Verde Butte, in Palo Verde. Checking out ancient petroglyphs was (from left to right) Steve Curry, David Boone, James Curry, Bill Boone, and Lee Wayne Johnson. Artifacts like those were also found by J. W. Simmons at the Van Liere site in Liberty and are preserved at the Buckeye Valley Museum. "Bringing the Past To Life By Preserving Our Local History" is a motto of the museum. (Then image courtesy of Nancy [Curry] Brainard.)

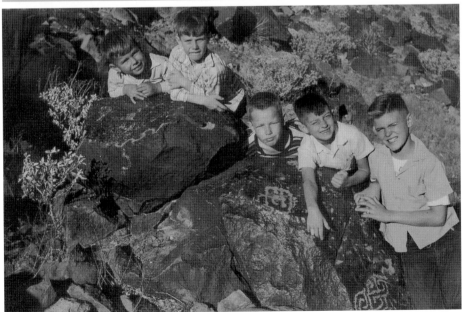

In 1948, the jagged slash running from the foothills to the peak of the eastern slope of the White Tank Mountains was originally the Caterpillar Tractor Company Proving Grounds. DMB Associates purchased the trail and surrounding area of 8,600 acres in 1998. Verrado was founded in 2002, with its grand opening in 2004. On April 24, 2009, a ribbon-cutting ceremony was held at the Jackson Building, located on Main Street (pictured above, at left). The building was named in honor of M. M. Jackson, who founded a canal in 1885 and named it Buckeye. A question: how did the White Tank Mountains get their name?

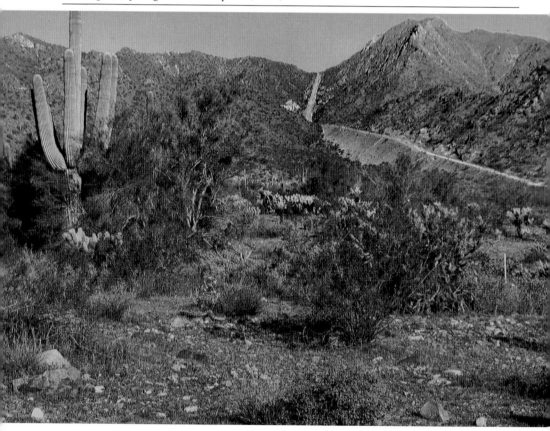

SCENES AROUND THE VALLEY

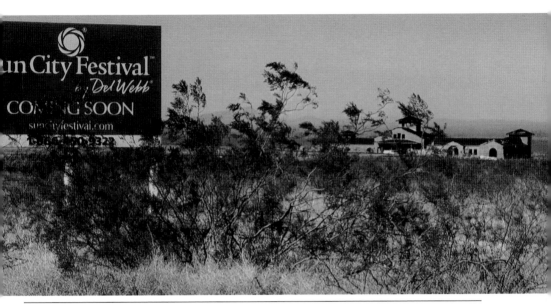

Buckeye continued to grow in land size and population with the arrival of Sun City Festival in 2006. On November 11, 2008, the 1,000th Festival Home Owners were recognized. From left to right, John and Lynn Long were given a key by Mayor Jackie Meck and councilman David Hardesty.

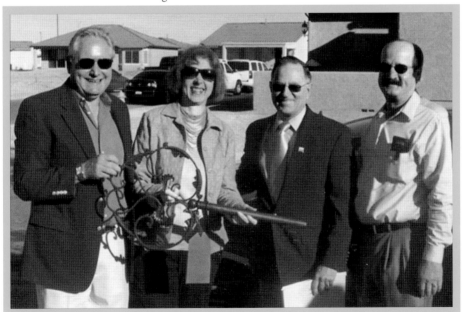

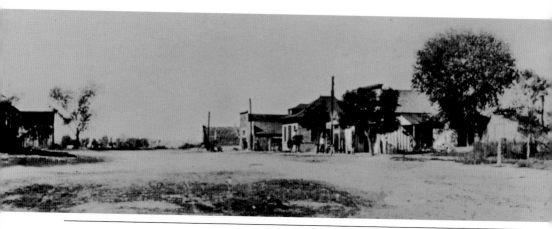

Centre Avenue was Buckeye's main street until 1910. The former Kell Store is on the north side of Centre Avenue near Sixth Street. It is the only original building still standing on Centre Avenue. In the 2009 photograph below, it is now a private residence. (Then image courtesy of Buckeye Valley Museum.)

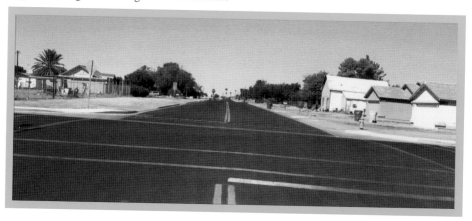

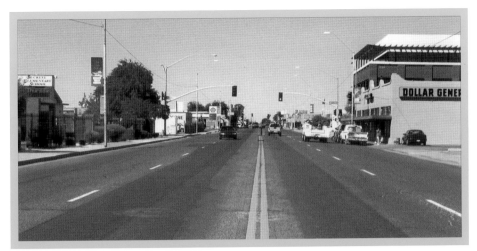

From the same location two very different scenes are shown. The then image (taken in 1959) is Monroe Avenue (Highway 80) looking west at Sixth Street. The now image (taken in 2009) is also Monroe Avenue (Highway 85) looking west at Sixth Street. (Then image courtesy of Buckeye Valley Museum.)

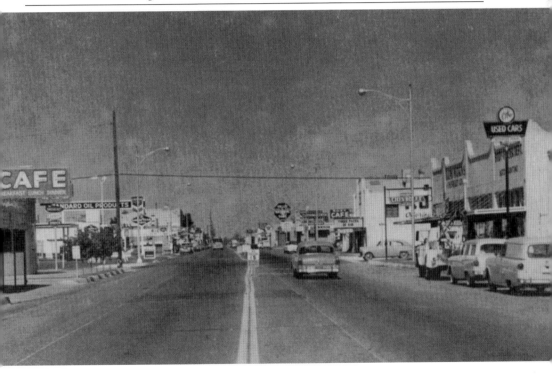

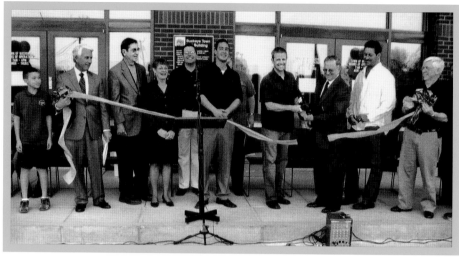

In 1935, the new $25,000, eight hundred–seat Roxy Theatre opened on Christmas night at Sixth Street and Monroe Avenue with full fanfare and a dedication ceremony. Below, in the 1950s, moviegoers lined up to view one of Hollywood's latest features. The Buckeye Town Hall, built by CORE Construction, is now located on that site. With an October 8, 2009, open house and the third annual Taste of Buckeye festivity, Mayor Jackie Meck (third from right) and chamber of commerce president Todd Hornback (fourth from right) cut the ribbon for the new town hall (shown above). Boy Scout Troop No. 263 posted the colors, and choir members from Verrado Middle School sang the national anthem. (Then image courtesy of Buckeye Valley Museum.)

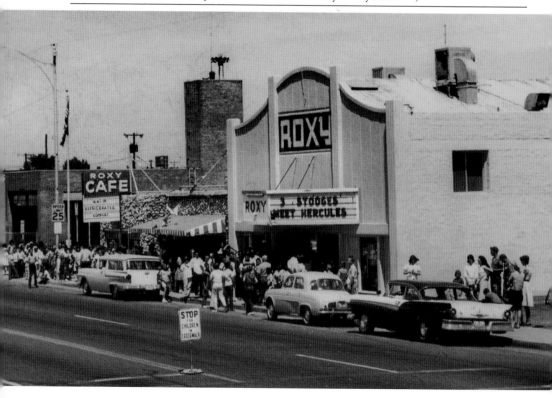

SCENES AROUND THE VALLET

CHAPTER 2

THE VALLEY AT WORK

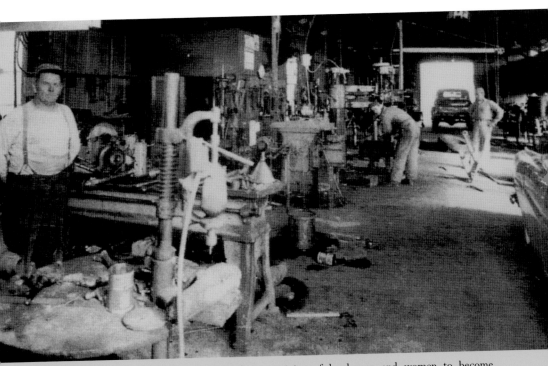

Blacksmithing came to Buckeye in 1929 when Francis "Frank" Leo Mulville opened the Buckeye Blacksmith Machine Shop. Mulville was approached by the Organized Buckeye Valley and Harquahala Valley Farmers and Ranchers, who were in desperate need of an accomplished blacksmith/machinist/welder. These men included Bud Bates, Lester Way, Coke Elms, Fred Kallenberger, Bernard Gillespie, Beloats, Longs, Buckelews, and Stevensons. They recruited Mulville and guaranteed him sufficient work to stay in business at a profit. Later a successful Welding Training Facility was organized in the shop for the instruction and training of local men and women to become productive welders, desperately needed in the World War II effort. Francis Mulville and his wife, Rose, raised 10 children. The business was sold to Merlin "Bud" Huff in 1951, who retired in 1971, and the business was dissolved. Pictured above in 1946 are (from left to right) Frank Mulville, Bud Huff, and an unidentified customer. The shop was located on property at Third Street and Jackson Avenue, where St. Henry's Catholic Church now stands. (Then image courtesy of Yvonne (Powers) Carlisle.)

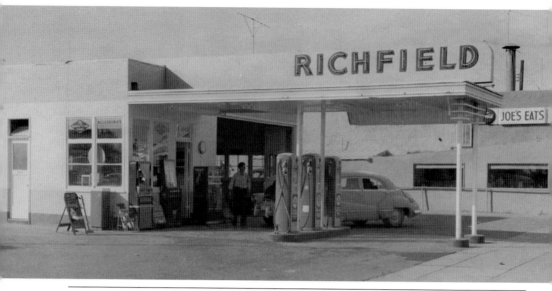

Joe Marshall's hamburger café, known as Joe's Eats, brings a memory from Paul Mattox, "When the lunch bell would ring at BUHS, the race would be on to Joe Marshall's Hamburger Shop. He would already have some meat cooking. His hamburgers would always be quick and good. They were some of the best that I have ever eaten. This is a part of my life that I've never forgotten." In 2009, the café location was still on the left side of the building next to Benbow Park on Monroe Avenue. (Then image courtesy of Buckeye Valley Museum.)

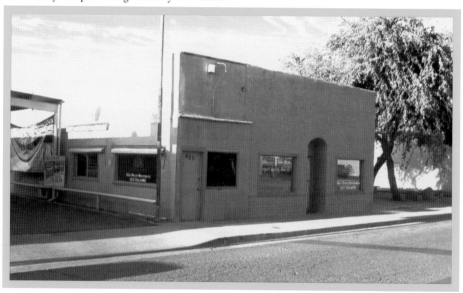

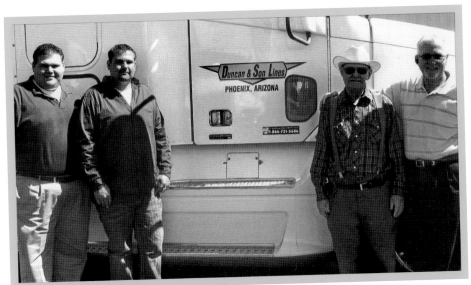

In 1943, Duncan and Son Lines, Inc., located just east of Buckeye on Highway 85, was founded in Buckeye, Arizona, by Richard Blaine Duncan Sr. (Blaine). One purpose of the business was to haul cotton, grain, and hay throughout the southwest portion of the United States. He began with two flatbed trucks. Pictured below is the first load of cotton hauled by trucks out of the state of Arizona. In 1974, R.B. Duncan Jr. (Richard) took over the company, and 70 trucks were in use. In 1997, Richard Blaine Duncan III (Rick) took Duncan and Son Lines international, specializing in the import and export of ocean cargo containers to and from the West Coast. Pictured above in 2009 are (from left to right) David Duncan, Blaine Duncan, Richard Duncan, and Rick Duncan. For more than 65 years, they have kept on truckin'! (Then image courtesy of Eric Liebe.)

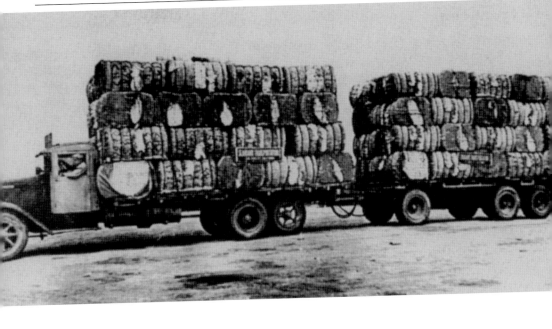

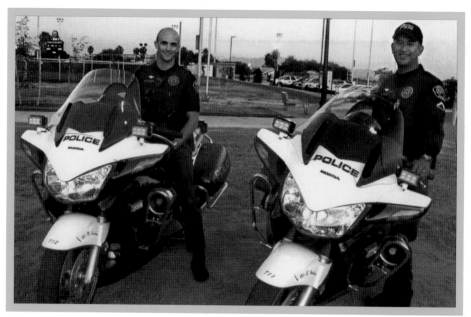

In 1953, police chief Charlie Post (left) showed highway patrolman Jack Abel a new one-hour parking sign to be located downtown. The 2009 police department includes Buckeye's first motorcycles, purchased thanks to a grant from the governor's office on highway safety. Above, patrol officers Rob Snider (left) and Erick Hamlin focus on enforcing traffic laws on Buckeye streets. (Then image courtesy of Bill Meck collection.)

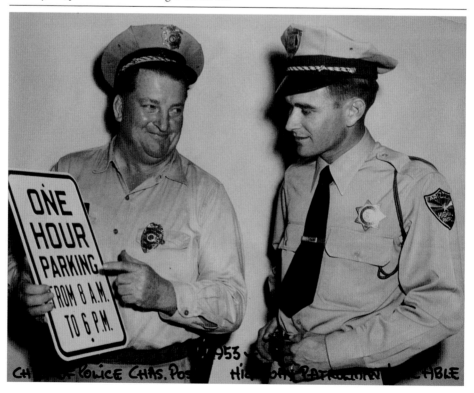

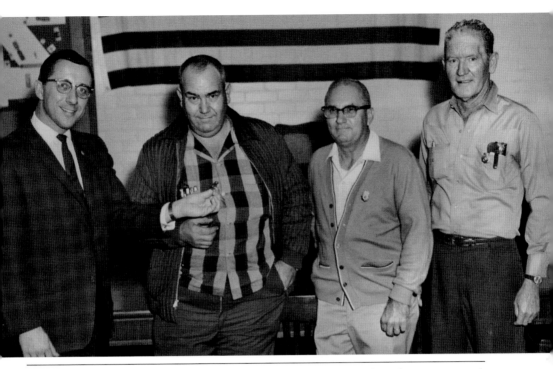

Volunteer service was recognized when 25-year pins were presented to the Buckeye Fire Department. Pictured above from left to right, Mayor Bob Bonnes honors Lester Currens, Wilbur Weigold, and Ivan Hendrick as they retired from the department in 1966. At the town hall open house in 2009, nine of 84 squad members were pictured. They are, from left to right, Dave Chappell, Mike Russell, Brett Gunsalus, Ken Welsch, Chrissy Yates, Marty Meece, Aron Webster, Marcus Haynes, and Stuart Esh. The fire chief is Bob Costello. (Then image courtesy of Buckeye Valley Museum.)

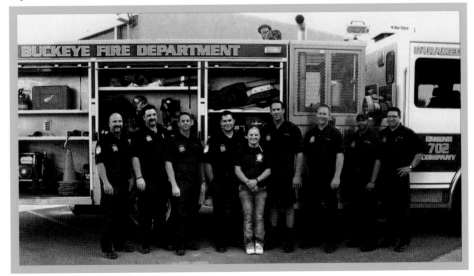

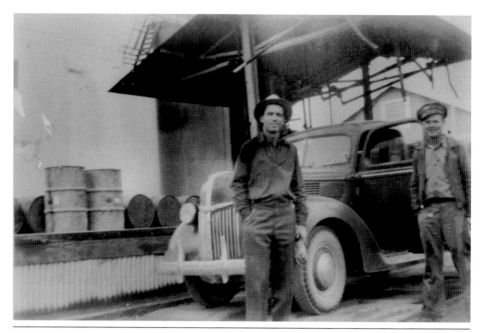

The Shell Oil Company in Buckeye, located east of Fourth Street, was started in 1931 by L. D. McDonald after the bulk plant was built in 1929. McDonald (left) is pictured above with employee Howard Henry around 1934. Lanier Calvert bought the company from L. D. McDonald in 1968. It is now the Calvert Oil Company. Below, standing at the same dock is (from left to right) David Calvert, Alan Calvert, Lanier Calvert, Santos Gonzales Jr., and Paul Lowe. The dog, Rimula, is named after a type of shell. The Shell Oil Company has named oils after seashells. (Then image courtesy of Alan Calvert.)

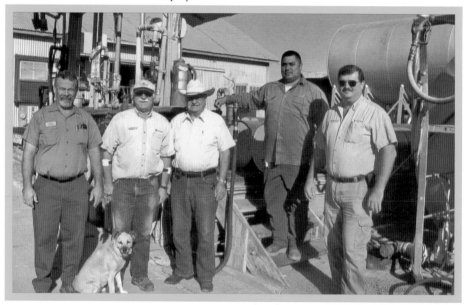

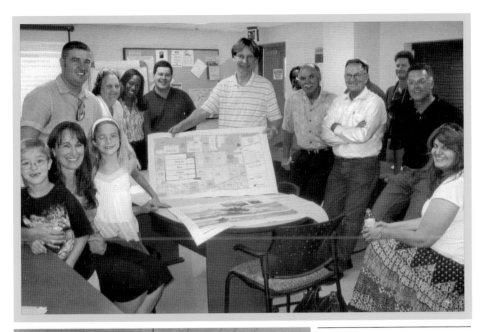

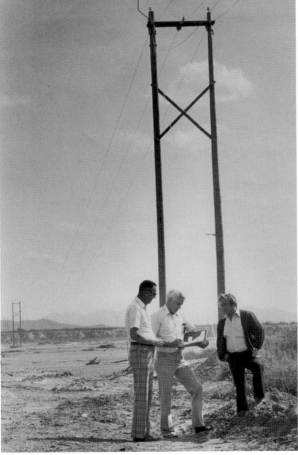

Energy has been generated in the West Valley for many years. Arizona Power and Light Company installed the first street lighting system in Buckeye in 1929. Shown at left in the early 1970s, Arizona Public Service, along with Larry Mattison (left), Roy Ellis (center), and Andy Anderson, began talk of a nuclear power plant. The result is the largest nuclear power plant in the United States. Palo Verde Nuclear Power Plant is located in Tonopah. Sempra Energy Mesquite Power Plant met on July 16, 2009, with local citizens to share solar power projects south of the Palo Verde Plant. Plans are to begin in 2010. Among those pictured above are Doris Heisler, Jackie Meck, Penny McGuire, Joe Rowley, Mike Sullivan, Mark Haarer, Deanna Kupcik, Heidi Vasiloff, and other planners.

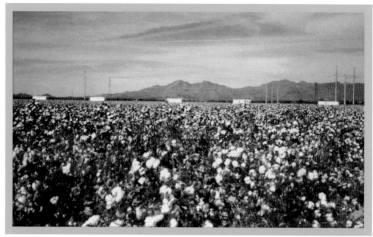

In 1920, the Dunlop Tire and Rubber Company built a cotton gin to process the new crop that farmers eagerly planted. Cotton prices dropped within the year, causing alfalfa, grain, and dairy to reemerge as the primary agricultural pursuits. Cotton arrived big time in the 1930s. Cotton gins, which separate cotton fibers from seeds, became prevalent throughout the valley. White, fluffy cotton waited to be picked and transformed into "the fabric of our lives." Below, farmers such as W. T. Gladden (left) and Chuck Youngker go through nearly nine months of preparing, which includes seeding and nurturing cotton plants and soil, before the cotton is picked in late fall. These scenes are changing as agricultural land succumbs to the relentless machine of change. Clyde Wilson, Charles F. Youngker, and W. Bruce Heiden have served as presidents of the National Cotton Council. (Then image courtesy of Buckeye Valley Museum.)

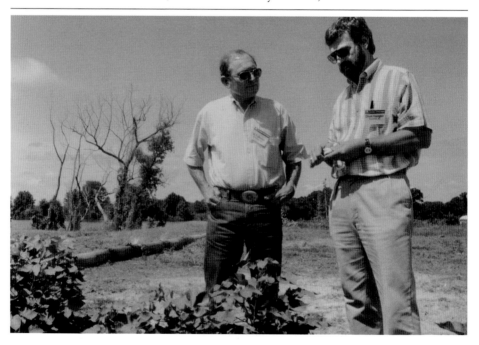

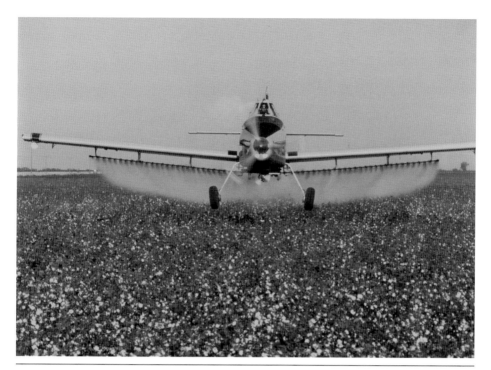

In 1993, third-generation farmer Hal Heiden of Heiden Air defoliated cotton on Heiden's H-4 Farms, located on Rooks and Broadway Road. The airplane Hal was flying is an Air Tractor 502. Now, with new technology from chemical companies causing fewer pink bollworm problems, aircraft are used less often. Spraying cotton has replaced crop dusting. On September 24, 2009, Dean Rovey sprayed cotton on the Flying R Farm, located on Airport Road near Broadway. (Then image courtesy of Hal Heiden.)

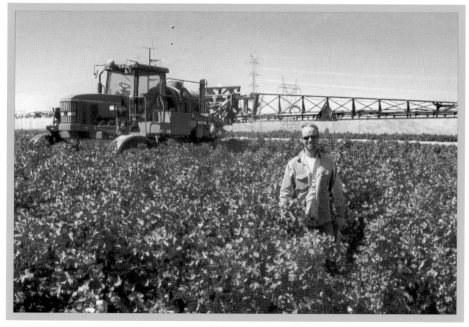

It is time for a doctor from the Southwest Family Practice, LLC, located at 1209 North Miller Road, to take up a position next to the field. Dr. Matthew Duke continues a 40-year legacy begun in 1951 by the late Dr. Robert A. Saide as team physician watching over Buckeye Union High School (BUHS) football games. Pictured below in 2009, Dr. Duke and his son, Aaron, stand on the sideline, ready to serve.

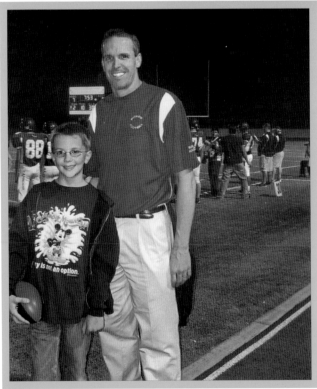

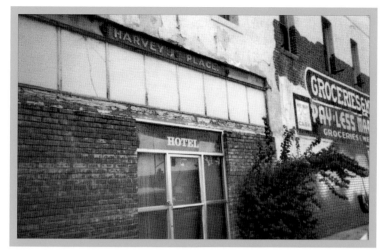

According to a June 5, 1919, *Buckeye Valley News* article, "Mr. William Major arrived in Buckeye last Friday with his stock of drugs, furniture, and fixtures. His family, a wife, Mary, and four children accompanied him. He is now busily engaged arranging and placing his stock and he assures us he will be ready to serve the public in a few days." In *BUCKEYE*, the Buckeye High School 1929 yearbook, the Majors Pharmacy advertisement read, "It pleases us to have students and teachers make our store and fountain a pleasant gathering place." According to the March 23, 1943, *Arizona Republic,* Majors Pharmacy engaged the services of a veterinarian with the object of rendering consultation services to ranchers and farmers. Majors worked until 1945. When he retired, George Sieffert became the pharmacist. Sieffert closed the pharmacy in the late 1950s, and the storefront returned to its original look. The location was at Fourth Street and Monroe Avenue, where a pool hall called Harvey's Place and a hotel was located. (Then image courtesy of Linda [Armstrong] Davis.)

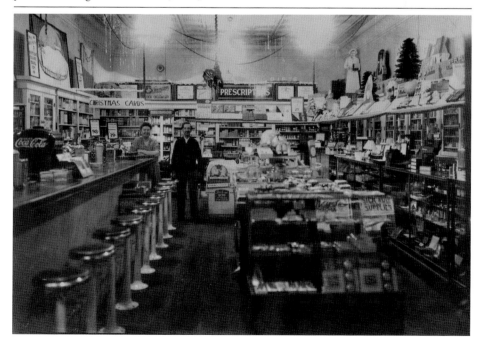

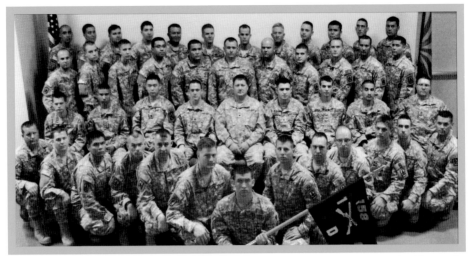

National guardsmen from the Buckeye Valley mustered outside the first Buckeye jail on Centre Street in the early 1900s. According to a July 21, 1938, *Buckeye Valley News* article, a detachment of six men from Company B reported for a 15-day guard duty at the Arizona State Prison at Florence. The Buckeye group consisted of Lt. Clyde Caffey, Sgt. Billy Meck, Cpl. Glen Martin, and Pvts. Keith Couch, Bill Johnson, and Howard Martin. Their headquarters was an armory building on the south side of Monroe Avenue between Second and Third Streets. Now the Arizona Army National Guard and Buckeye Armed Forces Reserve Center is located north of the I-10 Freeway on Miller Road. A grand opening was held on July 23, 2009. Stationed there is Unit Delta Company 1-158th Infantry. (Then image courtesy of Buckeye Valley Museum; now image courtesy of Sandy Mallach.)

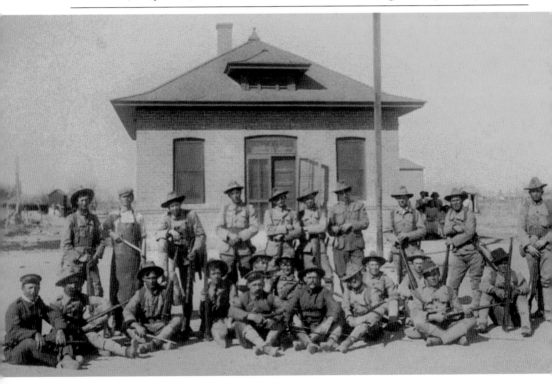

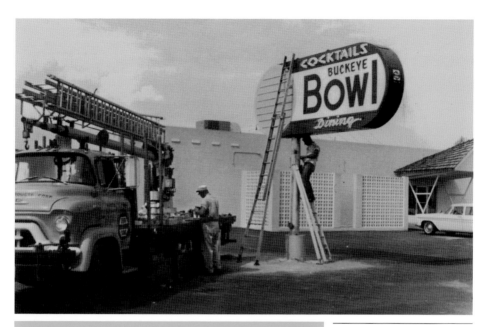

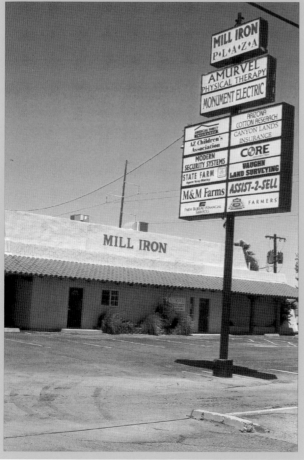

A sign was erected around 1962 to invite people to the Buckeye Bowling Alley and Restaurant, located 1 mile west of downtown Buckeye. After it closed in 1968, the building was used for a short time as a teen dance hall. Later the building housed the Mill Iron Restaurant, Agriculture Services, and Computer Tax Accounting businesses until around 1982. It became the Cotton Junction Restaurant around 1990. In 2009, the Mill Iron Building housed many businesses in the Plaza. (Then image courtesy of Buckeye Valley Museum.)

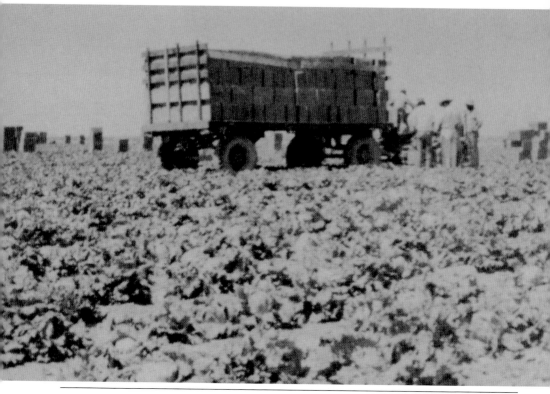

The Martori family in Harquahala Valley provided many opportunities for harvesting lettuce in 1955. Now a new venture, called Sunbelt Transplants and Vaquero Company, owned by Mayfield Farms, has added onions to the valley agriculture scene. Sunbelt Transplants is located on Airport Road north of Broadway Road. (Now image courtesy of Carrie Mayfield.)

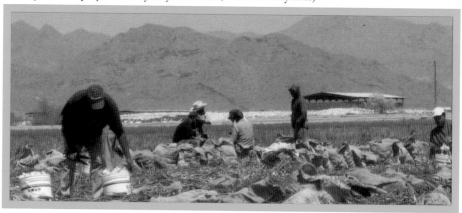

Stacking hay by using a sling and derrick in the early 1940s provided hay for livestock. Today the stack is called a bale, and a tractor baler machine picks it up. One of the farmers, Steven Bales Jr., is a fifth-generation farmer located on Beloat Road. A rural roadway, Beloat takes its name from Bales's early ancestors, who settled in Liberty during the 1880s. In today's environment, the pleasant aroma of freshly cut alfalfa is a reminder of Buckeye's agricultural heritage. (Then image courtesy of Buckeye Valley Museum.)

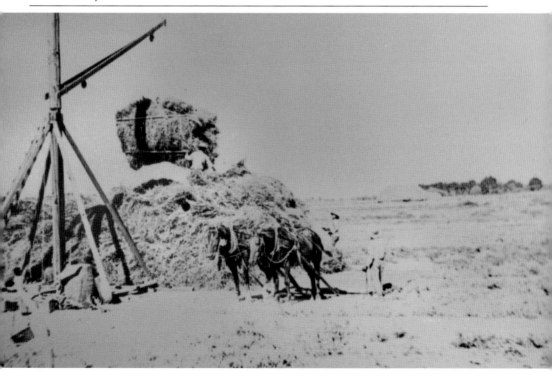

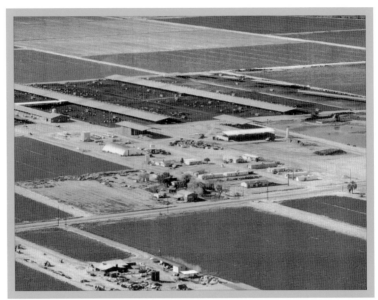

Milking time came twice a day in 1930 for Lydia Shepard. On the V. O. Shepard farm and dairy, she milked by hand. After Lydia separated the milk into cream and made butter, she drove to George's Market (later Abraham's in Buckeye) and traded it for groceries. Today's dairies milk around the clock. The Saddle Mountain Dairy, owned by W. T. and Dan Gladden, located on old U.S. Highway 80 in Palo Verde, is an example of a modern-day dairy. It was built to house 3,244 cows, which are milked around the clock, 72 at a time. Operations began in November 1999. Remembering some dairies from the past brings to mind Long's, Beckworth's, and Brewster's. Today's modern dairy scenes contain familiar names such as Gingg, Lueck, Allen/Hardesty, Butler, Keiper, Van Leeuwen, Kerr, Boschma, DeYoung, and Dickman. (Now image courtesy of Sheri [Narramore] Gladden.)

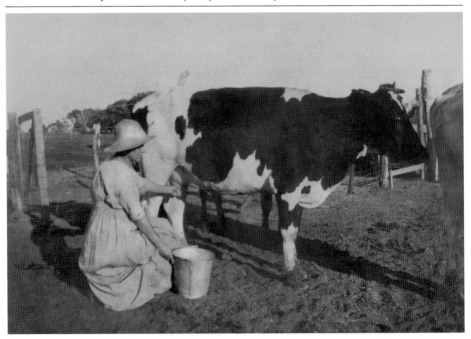

THE VALLEY AT WORK

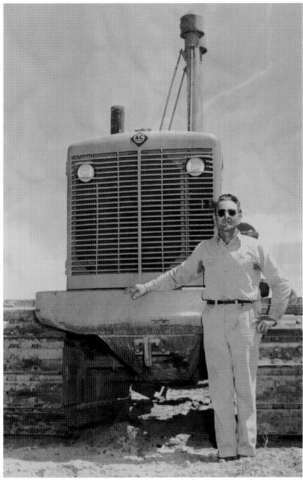

From the Caterpillar Tractor Company in Illinois, an October 17, 1938, photo caption of L. G. Stephens of Stephens and Beauchamp in Buckeye, Arizona, says, "When we started in business we watched all makes of track-type tractors work, and we selected Caterpillar diesels as the cheapest to keep up and operate. Two years' experience with two diesel thirty-fives and our new D6 have convinced us that our first judgment was correct." As pictured in 1952, he continued to move dirt. L. G. (Dewey) Stephens was the longtime owner of Stephens Land Leveling, located a half mile west of Buckeye on U.S. Highway 80 (now M.C. 85). Dewey retired around 1980. Dewey's son, Larry, shown below in 2010, now owns and operates Westside Excavating, and dirt continues to be moved. (Then image courtesy of Murel and Connie Stephens; now image courtesy of Tracey Stephens.)

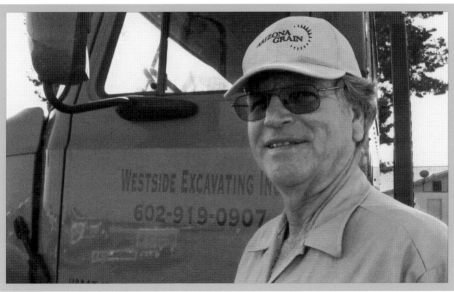

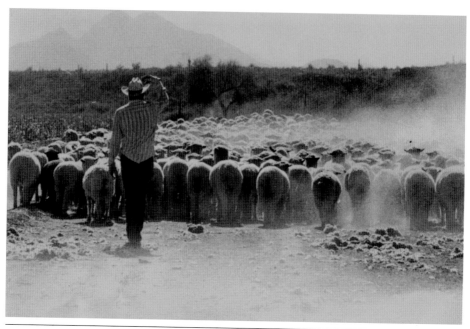

Bringing a Basque sheepherding heritage from Spain was the Manuel Lavin Aja family in 1934 and the Echeverria family in the 1950s. Aja established a sheep camp headquarters on Broadway Road just west of the cemetery. During the spring and winter months in the 1950s, scenes like this became familiar around the valley. Manuel's son, Basilio, herds a flock of range Rambouillet ewes to another field for grazing. Four generations later, the Aja family still has its roots in the town. In 2009, well-known artist Loretta Musgrave, a former teacher at Arlington Elementary School and Buckeye Union High School, created a painting of that scene. At the Buckeye Town Hall open house in October 2009 Basilio (Bass) sees the results and duplicates the "arri arri" (get moving) command. Musgrave painted 18 beautiful Buckeye history scenes for the new town hall. (Then image courtesy of Irene [Echeverria] Aja.)

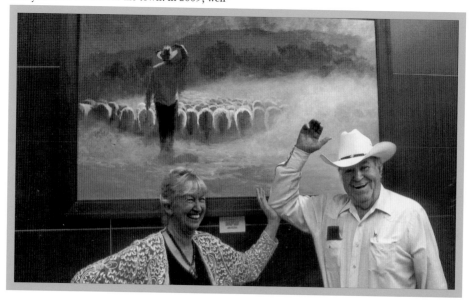

CHAPTER

THE SPIRIT OF THE
COMMUNITY
HERE AND THERE

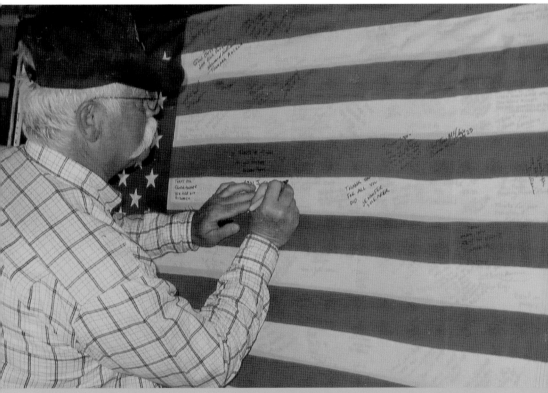

On April 1, 2009, approximately 180 American Veteran Motorcycle Riders escorted the traveling Vietnam Wall tribute through Tonopah to Verrado High School. The wall is a replica of the Vietnam Memorial Wall in Washington, D.C., complete with every name as on the original. Buckeye's American Legion Post No. 53 was instrumental in bringing it to the valley. Tonopah resident "Cactus Jack" Caratachea signs a flag, which accompanied burials to Arlington National Cemetery in Washington, D.C.

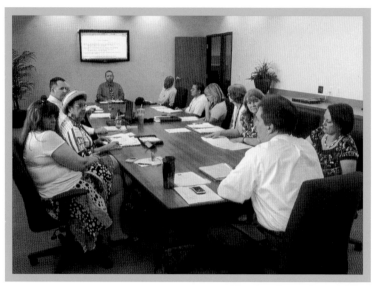

Community leaders in 1967 met at the courthouse/jail on South Fourth Street and made plans for the 1st Annual Pioneer Days Celebration. Identifiable leaders pictured include Pete Narramore, Louis Joslin, Bill Flower, Bill Meck, Leslie Grandy, Dean Malan, Clemie Arnold, Lola Johnson, and Hilda Harder. Beginning in 2008, a strategic planning committee named "We Are Buckeye" began developing a vision for Buckeye through resident interviews. Some of the committee members in a September 9, 2009, planning session are Deanna Kupcik, Verlyne Meck, Matt Muckler, Stan Goldman, Dee Hathaway, Greg Clemmons, Larry Laurita, Sandy Mallach, Annette Napolitano, Robin Polk, Chris Larson, and David Johnson. Not pictured are Sherry Saylor, Sorin Puscau, and Mark Lantvit. (Then image courtesy of Buckeye Valley Museum; now image courtesy of Bob Bushner.)

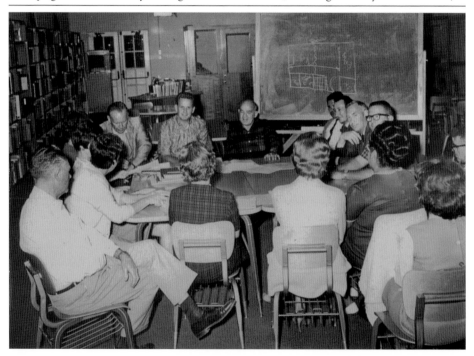

THE SPIRIT OF THE COMMUNITY HERE AND THERE

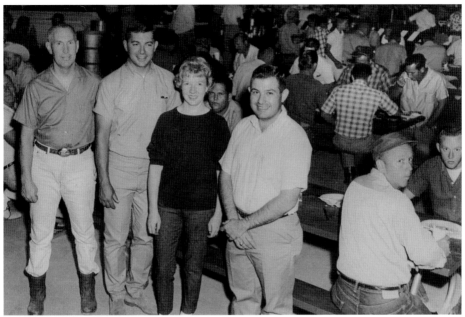

The Buckeye Park plays host to many eating festivities. For many years in September, Dove Hunter's Breakfast, sponsored by the chamber of commerce, fed many hungry early-bird hunters. Pictured above from left to right are Dean Malan, Robert Doster, Lois Armstrong, and Joe Wolf, who helped with the details. Also Mildred Biddulph, in Mildred's Restaurant, prepared "Dove's Buckeye" for hunting visitors in the 1950s and 1960s. Her original recipe, provided by Tony and June Scarbino states, "After the birds have been cleaned, soak in salt water for several hours. Dust with flour and white pepper. Brown in hot fat (Crisco type). Drain well and place in roaster. Add chicken broth: can be made with bouillon cubes, wine, and orange juice. Bake in a slow oven for 1 to 2 hours, turn, and baste. Add more liquid as needed. Good Luck!" Now the park plays host to the Countryfest Holiday Boutique in November, which is sponsored by the Buckeye Community Services Department. At one event, Sally Sedig serves her mouthwatering lemon meringue pies.

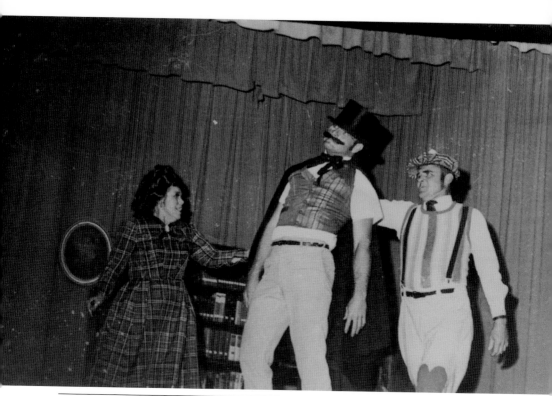

Villains and Pioneer Days melodramas go together. Murel Stephens capably filled the villain role in the 1972 performance of *Dora the Beautiful Dishwasher* as Mary Joslin and Harvey Cambron caught him. Then Caleb Elms (below, fourth from left) got the boos in 2009 at the 42nd annual melodrama *Someone Save My Baby Ruth!* A memory that attendees will never forget is the song "Don't Forget Me Song," sung by Les Meredith. (Then image courtesy of Connie Kirchoff Stephens.)

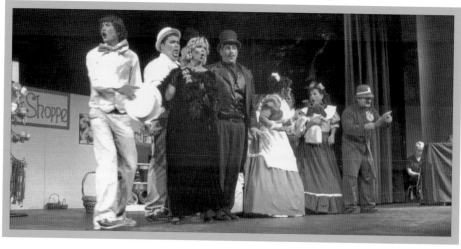

THE SPIRIT OF THE COMMUNITY HERE AND THERE

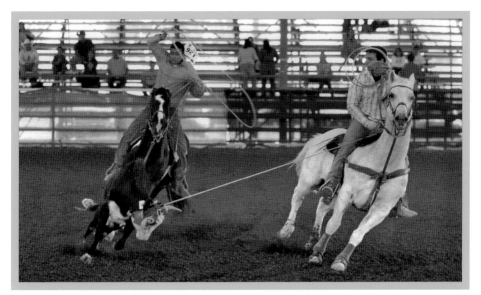

Buckeye Helzapoppin cowboys of days past performed at the rodeo arena located east of Fourth Street and south of the railroad tracks. Around 1958, BUHS classmates Terry Couch (pictured below, bull rider) and Art Arnold (team roper) awed fans with their rodeo skills. Buckeye old-timers remember cowboys such as Ross Roberts, John Osborne, Carl Arnold, John Beloat, Jack Narramore, and Jack Gable. Shown above performing at the new Buckeye Equestrian Center on South Miller Road in 2009 are team ropers Clayton Brunson (header) and Sam Marquez (heeler). In 2009, Troy Nahrgang was named Arizona State High School All-Around Cowboy in steer wrestling. Some of the other top high school rodeo competitors from Buckeye are Trey and Meagan Nahrgang, Austin Butler, Kayla Karstetter, Lauren Barnes, Shelby Jo Perez, Stormie Olaiz, Jessi Ramirez, Sarah Edwards, Mariah Kerr, and Jake, Whitney, and Torey Mayfield. (Then image courtesy of Susan [Couch] Cox; now image courtesy of Janna Brunson.)

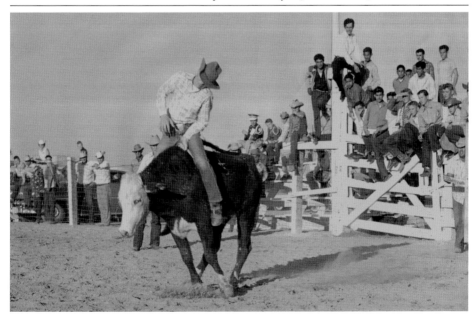

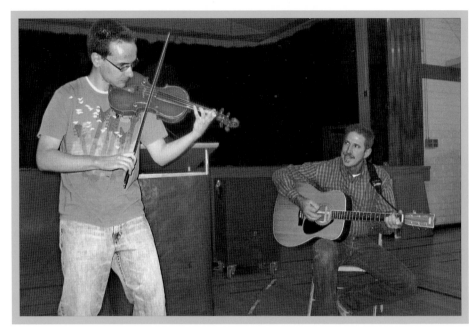

In 1942, the Old Time Fiddlers performed at the Buckeye Valley Old Settlers Reunion in Palo Verde. The group included Tom Stansberry, Oscar Roberts, Will Davis, Charley Davis, and Dolph Evans at the piano. The fiddler at the 2009 Old Settlers Reunion (pictured above) was Bryce Boydston from Palo Verde, accompanied by his uncle, David Lanford. (Then image courtesy of Buckeye Valley Museum.)

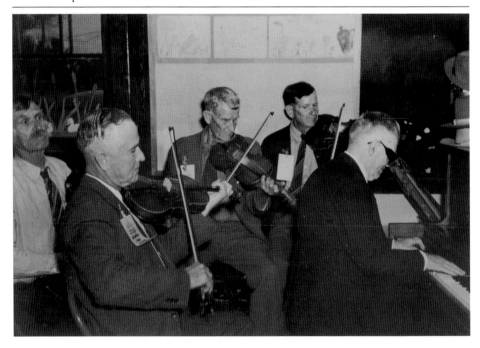

THE SPIRIT OF THE COMMUNITY HERE AND THERE

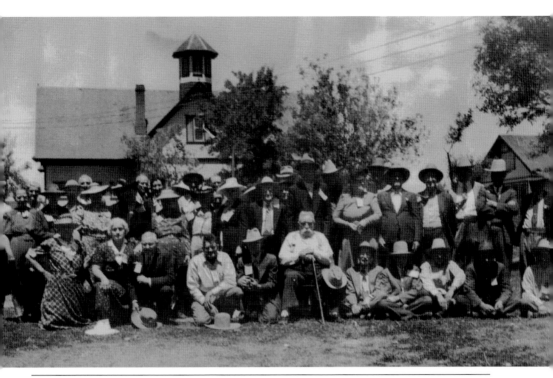

The Buckeye and West Gila Valley Old Settler's Union was established in 1933. Its purpose was "To perpetuate old memories and friendships and to establish new ones. As a pledge to those who first suffered hardships and privation, that the deserts of the valley might be made to blossom, and to preserve in our communities the 'spirit of pioneering' that it may not be forgotten by our descendents." Palo Verde School was the gathering place in 1941 (above) and in 2009 (below). Pres. Paul Bruner presided over the 76th noontime potluck/meeting. Later Tom Roberts rang the memorial bell in honor of pioneers deceased since the 2008 gathering. (Then image courtesy of Buckeye Valley Museum.)

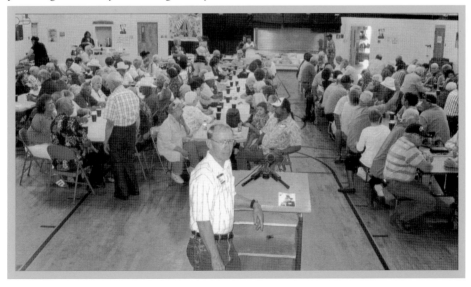

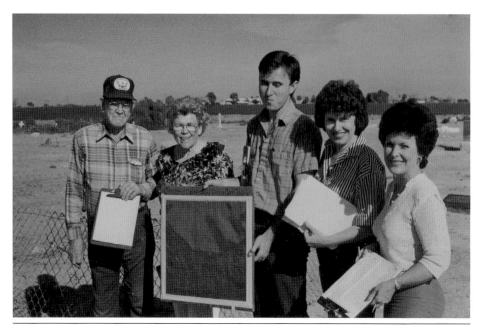

A Daughters of the American Revolution (DAR) chapter was started in Buckeye in June 2006, with Beverly Kerrigan as the first president. Pictured above from left to right, Vernon Beloat, Edith Mae Christian, Steven Bales, Barbara Bales, and Loretta "Sissy" Black researched the valley's first cemetery in Liberty for Buckeye's 1988 Centennial. Building on their research, and with information from *Buckeye Valley News* and Arizona state archive records, members Jean Denman, Linda Davis, Linda Sanders Hardison, and Joan Hardison (shown below, from left to right) worked to preserve the history of those in grave sites at three local cemeteries. They, along with Jean Denman, Pam Hobbs, and Maggie Hooper, volunteered to preserve the history of the Liberty, Palo Verde, and Buckeye cemeteries. (Now image courtesy of Linda [Armstrong] Davis.)

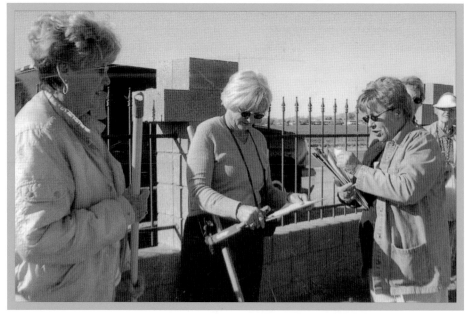

In 1973, Rainbow Valley was a growing small community and a place where mobile homes burned quickly. J. D. Dunivant and Jim St. Vincent took it upon themselves to begin a volunteer fire department and community center park. Paul Garen donated 3 acres on Narramore Road and Fire Station No. 326 began. Volunteers took eight weekends in 1974 to construct the fire barn and dedicated it in memory of the first fire chief, J. D. Dunivant, who died suddenly in 1976. At the dedication were, from left to right, (first row) Fred Dugan, Fred Probst, Darrell McCarty, and Charles Collins; (second row) Bill Gillard, Charles Melvin, Les Reynolds, John Honea, Jim St. Vincent, and Richard Wallace. In 2009, the fire barn was still in use, but a new fire station was to be built in 2010. (Then image courtesy of Jim St. Vincent.)

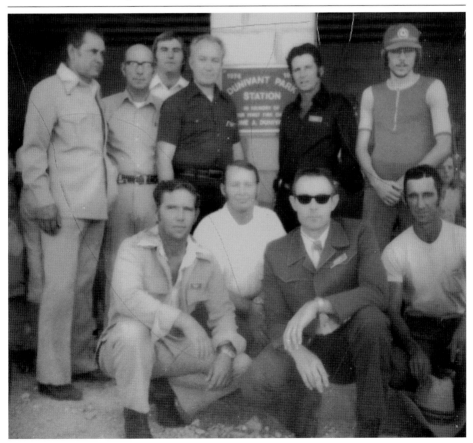

Little League Baseball began in the 1950s with volunteer leadership from Earl Edgar and financial support, plus manpower, from the Hazelton-Butler American Legion Post No. 53. The Giant Division Champions in 1960 were, from left to right, (first row) Roger Skaggs, Danny Martin, Ronnie Turner, Charles Henry, and Albert Grijalva; (second row) David Arnold, Marvin John, Roy Perez, Tommy Ybarra, Joe Valdez, Fermin Flores, and Gayle Eckleberry. It is noted that equipment manager of the teams, Joe Luquez, lost only one ball out of 106 during the season. After the Pledge of Allegiance on opening day in March 2009 at the Earl Edgar Recreational Facility, first pitches were tossed by (from left to right) Alex Villa, Frank Edgar, Dave Skousen, and Jackie Meck. Today's Little League volunteers include Kip Colville and Shawn Dunivant. (Then image courtesy of Charles Henry.)

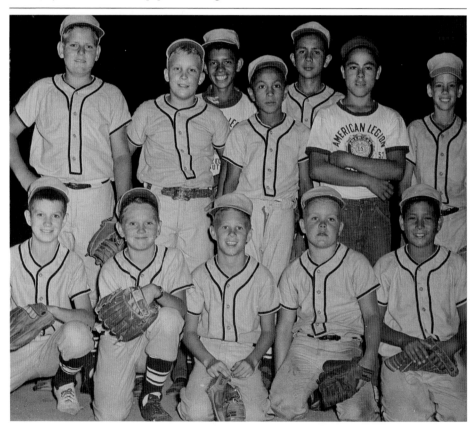

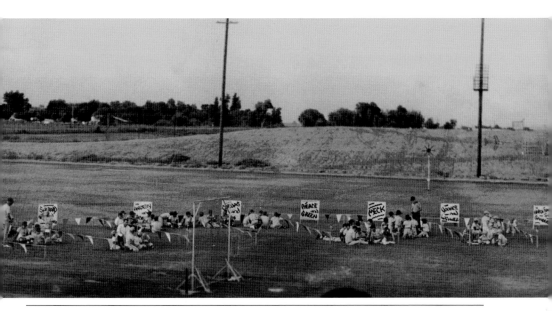

Little League teams gathered for drill and skill contests on July 4, 1965, on the BUHS football field. On September 19, 2009, at Youngker High School, the First Annual Buckeye Open Judo Championship Tourney was held. Sensi San (teacher) Dan Edwin Eng organized the Buckeye Thunderbird Judo (gentle way) Club in 1986. The honorary first throw (osoto gari) to open the tournament was given by Mayor Jackie Meck against Dakota Balavich with a (ippon) throw. (Then image courtesy of Earl Edgar Collection.)

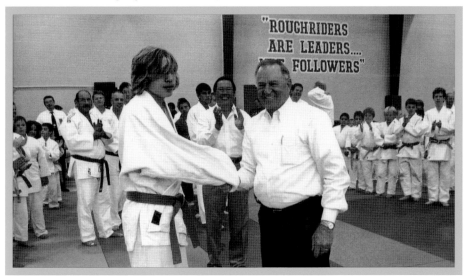

Heritage Days then (2008) and now (2009) recognized young citizens in a Lil' Mister and Lil' Miss contest. In 2008, Straton and Maily Hunter (pictured at right) were the first to receive the title. They are the children of Paul and Katie Hunter and are fifth-generation Buckeye Valley residents. In 2009, the Heritage Days Pageant winners were Kyle Rose and Tailynn Sue Sherman (shown below). Heritage Park Days are held on Eastman Gin property to raise money to build a new Buckeye Museum, outdoor amphitheater, 3 acres of agriculture fields, a farmer's market, and a working mini gin. (Both images courtesy of Janna Brunson.)

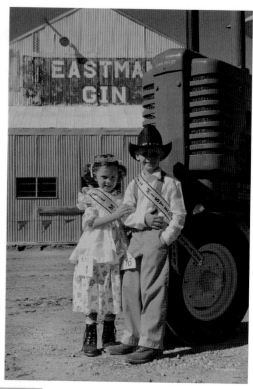

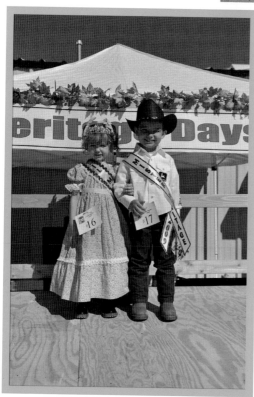

THE SPIRIT OF THE COMMUNITY HERE AND THERE

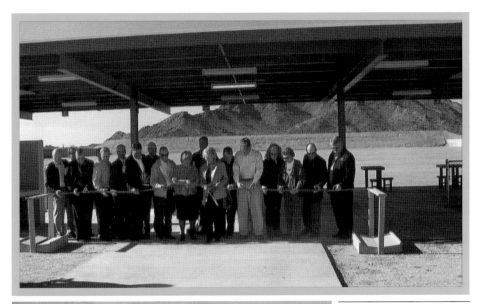

In 1961, the Helzapoppin Rod and Gun Club, established in 1946, sponsored Arizona hunter's safety classes. Those instructors were, from left to right, (first row) Buddy Currens and Benny Youngker Jr.; (second row) Noel Scott, Manuel Amabisca, Alvie Davis, and J. C. Coker. Now the club is known as the Buckeye Sportsman Club, with 55 members. In January 2009, they presided over a ribbon-cutting ceremony at the newly renovated Buckeye Hills Regional Park. It is now known as the General Joe Foss Shooting Complex. Vice Pres. Manuel Alvarez said the rebuilt complex provides a safe environment for shooters. (Then image courtesy of Paul Lowe.)

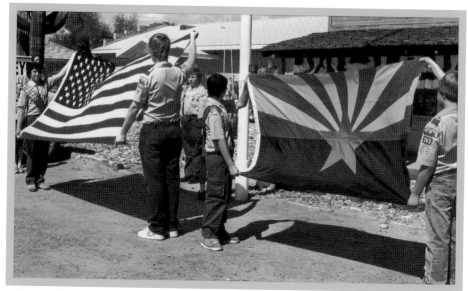

Raising the flag around 1962 at the Buckeye Valley Museum is the American Legion Color Guard: Rudy Ayala, Frank Villa, Frank Bon, and Alex Villa. Others pictured are Frank Armstrong, Joe Valdez, museum curator Ruth Thompson, post commander Pete Clemit, auxiliary president Fanny Thompson, Steve Villa, and Buddy Currens. American Legion Post No. 53 donated the pole and flag. On September 11, 2009, the Boy Scouts of Troop No. 263 raised a new flag, donated by the DAR. American flag presenters Paul Cross and Jared Ray joined Arizona flag presenters Stanley Heisey and Gabe Napolitano when Dallas Tolbert called them out. Eagle Scouts Cross and Tolbert refurbished the pole and ropes. (Then image courtesy of Linda [Armstrong] Davis; now image courtesy of Janna Brunson.)

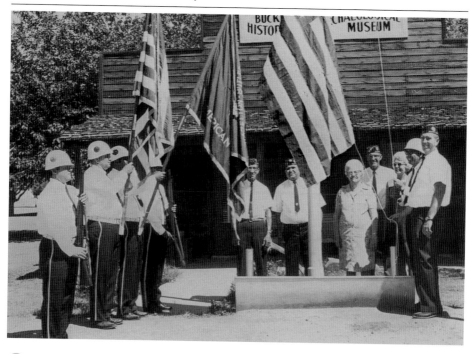

THE SPIRIT OF THE COMMUNITY HERE AND THERE

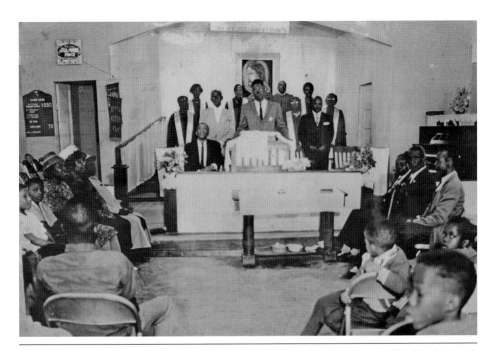

Built by Arthur Wilburn Sr., Mount Pleasant Church was a center of worship for the African American community and was first located in Allenville. The founding pastor around 1948 was Reverend Burdon, and from 1952 to 1954, longtime resident T. M. McGinty served as pastor. Families represented in the *c.* 1960 photograph are the McGinty, Austin, Wilburn, Washington, Allen, Kelly, and Coston families. When Allenville was abandoned due to floods in 1978, the church relocated to Fifth Street and Mahoney Avenue.

Now the church meets at 403 North Fourth Street. Pastor Richard Burrell and his wife, Prophetess Tammy Burrell, led an October 2009 worship service. Elders James McDonald and Arthur Wilburn Jr. and deacons Gale Taylor and Willis Wardlaw Jr., along with mothers Marva Perkins, Miller Wilburn, Frances McDonald, Essie Hundley, Elexive "Chucklebea" Lofton, and Elease Kemmer, served communion. The praise team was led by Tamarind Mitchell. (Then image courtesy of Arthur Wilburn Jr.)

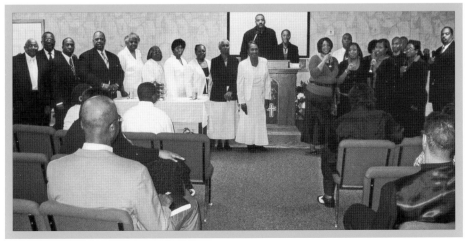

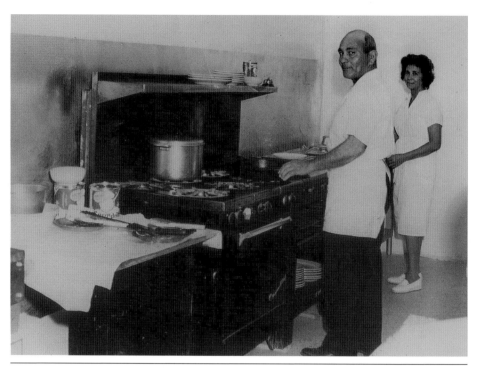

La Placita and Amabisca's go deliciously together with taco sauce and green chili cheese crisp. Manuel and Nellie Amabisca (pictured above) opened La Placita Cafe in 1962. Their son, Joe Amabisca, and his wife, Barbara, (shown below) became the owners and cooks of the well-loved restaurant in 1988. The newly remodeled Buckeye landmark is located at 424 East Monroe Avenue. (Then image courtesy of Anna Amabisca.)

THE SPIRIT OF THE COMMUNITY HERE AND THERE

Sitting and talking is a Buckeye favorite pastime. From a Couch and Benbow family gathering at Miller's Wash in 1965, to the coffee shop storytellers in 2009, legends are relived. Darla's Country Kitchen on Monroe Avenue was first Mildred's Restaurant and was known for Mildred's pies. After Mildred (Beloat) Biddulph sold the restaurant, owners through the years have been Mike Scarbino, Mike Ferante, Clarence and Kathleen Ames, and Ed and Darla Carter. Current owners are Greg and Grace Montes DeOca. On September 11, 2009, those present for their daily meeting were, from left to right, Detmar Holly, Jim Hardin, Robert Parker, C. W. Adams, Corky Narramore, Dan Naramore, and Jim Kieffer. It is still the place to catch up on stories by the "Coffee Shop Story Tellers." Missing in this photograph is the official storyteller president, Jack Gable, who was researching the story of how Miller Road got its name. (Then image courtesy of Susan [Couch] Cox.)

Service to Buckeye has always been a part of many residents' lives. Pictured below is the 1952–1954 town council as they met in the newly built town-county building at 508 East Monroe Avenue. Pictured from left to right are Francis Lancey, Joe Luquez, vice mayor Wes Biddulph, Mary Kallenberger, Mayor Jack Gable, Norma Perry, Ed Bartylla, and city clerk Wm. Thompson. Now the Buckeye Council meets in a new town hall, located at 530 East Monroe Avenue. The first work study session, held on November 3, 2009, at the new location, included councilman Dave Rioux, vice mayor Elaine May, Mayor Jackie Meck, councilman Robert Doster, councilman Brian McAchran, and councilman David Hardesty. Absent was councilman Robert Garza. Listening to finance director Gail Reese was interim town manager Stephen Cleveland, town attorney Scott Ruby, town clerk Lucinda Aja, and assistant Deborah Harrell. (Then image courtesy of Bill Meck collection.)

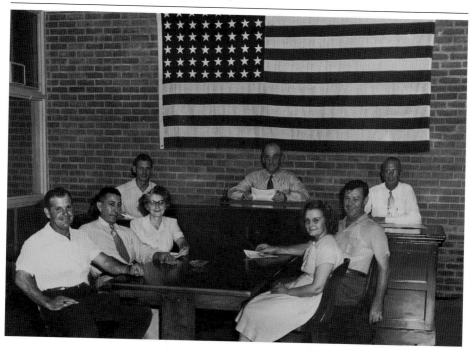

THE SPIRIT OF THE COMMUNITY HERE AND THERE

CHAPTER 4

SCHOOL DAZE

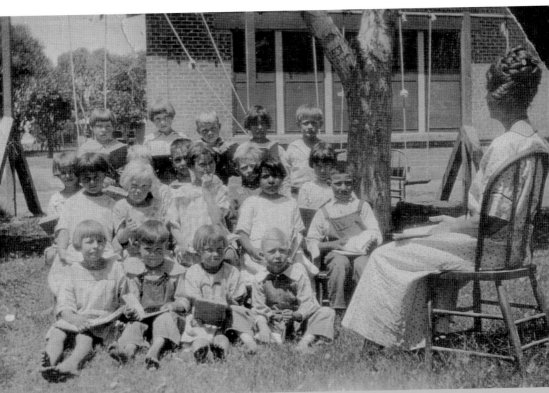

First- and second-grade students at Liberty School enjoyed reading time outdoors in 1923. On this same site on April 28, 2010, the Centennial Outdoor Classroom, designed by a Leadership West Team, was dedicated. Seeds for learning were planted with a variety of plants, trees, water features, walking paths, sitting areas, and a greenhouse.

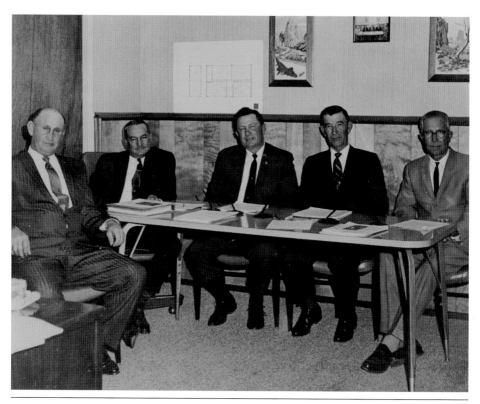

School board members at BUHS in 1963 were, from left to right, Murray Johnson, Charles Youngker, Sam Cambron, Paul Pierce, and Sam Richardson. Chester D. McNabb was the superintendent. Forty-seven years later, governing board members serving BUHS District No. 201, now with three schools, are (from left to right) Steve Warner, Craig Jones, president Gary Mayfield, clerk Becky Gifford, and Brian Turner. Governing board meetings are held in the Chester D. McNabb Building (the former school library). Dr. Beverly Hurley is the district superintendent. (Then image courtesy of BUHS Library Archives; now image courtesy of Kari Kline.)

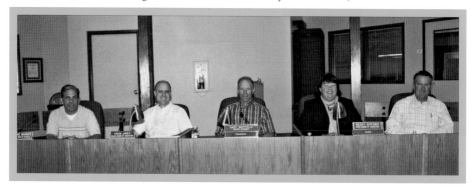

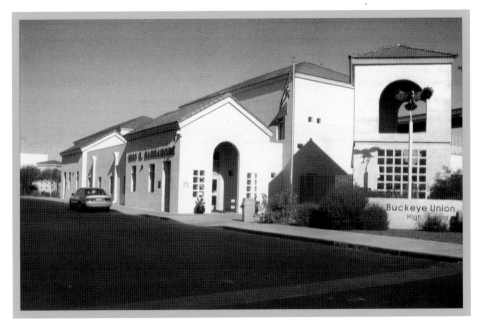

Buckeye Union High School (home of the Hawks) has been at three locations. Previous to opening the doors at 902 Eason Avenue on September 24, 1928, Buckeye High School met at the Buckeye Elementary School Sixth Street campus. The 902 Eason Avenue campus is pictured below as it looked in 1993. In 2010, principal Tawn Argeris presided over the 1000 East Narramore Avenue campus (shown above). The Buckeye Hawks landed in their new nest on January 5, 2004. (Then image courtesy of BUHS Library Archives.)

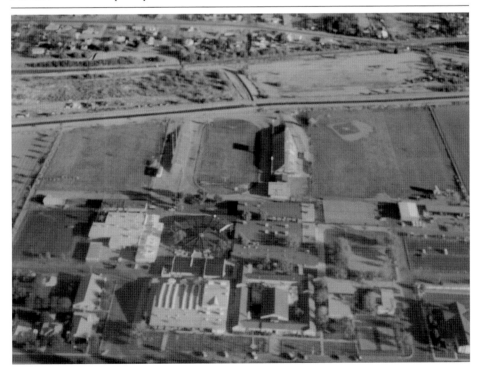

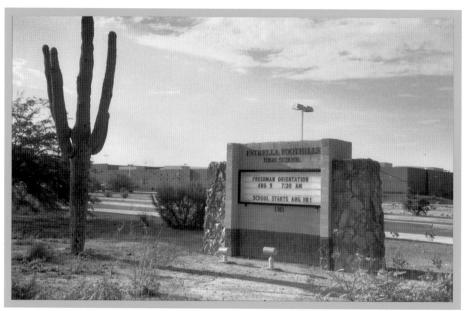

Estrella Foothills (home of the Wolves) is the second high school in the BUHS District. It is located at Estrella Mountain Ranch (EMR), and SunChase donated the 45-acre plot. The current principal is Dr. Leslie Standerfer. The name selected was submitted by community leader Alice Charman. Charman said, "May the faculty impart knowledge, the halls ring with laughter, the teams exhibit sportsmanship, and the students swell with pride as they represent Estrella Foothills High School." Ground was broken in September 2000 for a 2001 school opening. Below, turning the ritual dirt is (from left to right) Alice Charman, superintendent Dr. Henry Schmitt, EMR manager John Christensen, and Goodyear mayor Bill Arnold. It is noted the school is located in the City of Goodyear, but it is in the BUHS District.

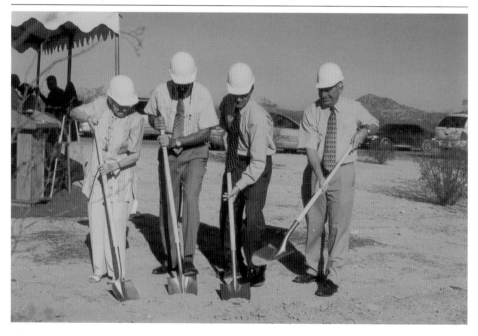

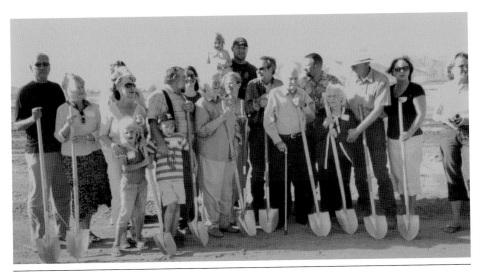

On April 17, 2006, ground was broken for Youngker High School (home of the Roughriders), located at Miller and Apache Roads. It became the BUHS District's third school. Youngker, a longtime Buckeye farming family, donated the 55-acre school site. Grace, Charles, and Martha Youngker are surrounded by the family at the ground-breaking ceremony. The school's architecture and colors are meant to honor the agriculture heritage of the area. Green, black, and white represent the colors of the crops, soil, and cotton. On August 8, 2007, principal Johnny Ray welcomed 300 members of the 2011 Youngker High School (YKS) class. On September 18, 2009, the stadium played host to its first varsity football game. Principal Ray, head coach Jason Stuewe, cheerleaders, and the YHS band and choir opened the inaugural game against Cortez High School.

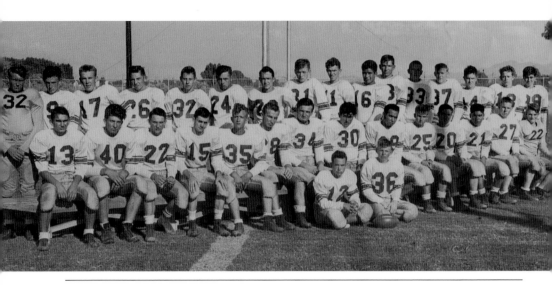

A new BUHS football stadium, able to seat 1,000 people, was dedicated on September 30, 1949. Fresh from a September 23, victory over Tolleson (18-0), the Mighty Hawks defeated Scottsdale High 19-0. The field, lit by 72,000 watts of electric lights, was designed to reduce glare for spectators and players alike. The lineup included Woody, Cantrell, Burns, Villa, Ganley, Roglin, Steves, Rainey, Mattox, Ellis, Sims, coach Clyde Dougherty, and assistant coach John Mallamo. The east-side bleachers were built in 1975. On August 28, 2009, a new press box and sprinkler-watered field was dedicated at Olsen Stadium. The Smith/Roberts track surrounds the football field. As a side note, when the west side stadium press box was being removed around 1985, BUHS choir director Don Kepler stood beside it and sang "The Star Spangled Banner." (Then image courtesy of BUHS Library Archives.)

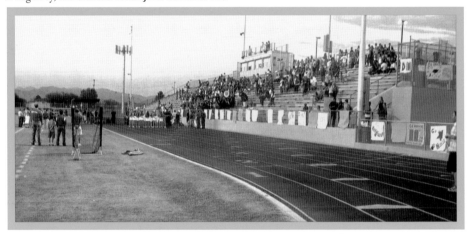

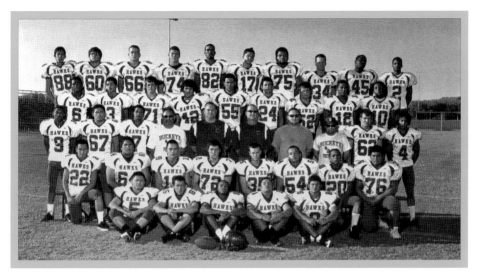

Performing in Buckeye's first football stadium were 1930 backfield team members (from left to right) Lewis Burke, Frank Hardy, Howard Hooten, and Vance Harer, with coach William Chester Vaughn. Other team members were Noel Jones, Francis Nichols, Tom Walls, Dudley Lewis, Ancil Leister, Ralph Schevene, Wallace Bales, Wiley Schweikart, Clarence Lyall, Herman Jagow, and Perry Anderson. That year the Hawks earned 96 points, compared to the opponents' 44 in a six-game schedule. The previous year, in 1929, Buckeye earned the Class "B" State Championship. The stadium was located where the McNabb Building District office is now. The 2009 team, coached by Bobby Barnes, had an 8-3 record and earned a playoff game against Paradise Valley in the Skyline 4A Division II State Playoff. Wayne Clark, a 1965 BUHS graduate and son of Roy and Marie Clark, was a NFL quarterback for the San Diego Chargers. (Then image courtesy of BUHS Library Archives; now image courtesy of Prestige Portraits.)

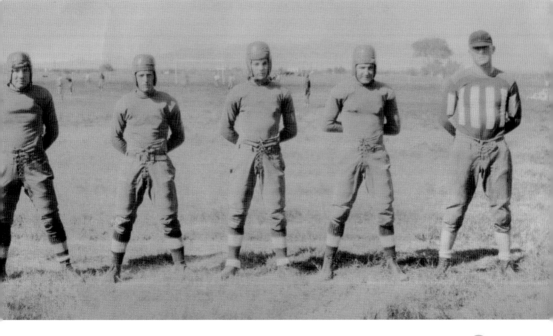

Until 1956, BUHS basketball games were played in the gymnasium on Eason Avenue, which was built in 1929. The 1953–1954 team was one of the last to play in the gym. Varsity Hawks were, from left to right, (kneeling) B. Bartylla, C. Arnold, B. Aja, R. Henry, and M. Perez; (standing) B. Bolton, D. Sedig, B. Sulzenger, K. Biddulph, B. Tollison, and coach Harry Ladas. In 2004, the 1956 gym was renamed Agee Gym in honor of coach Lenard Agee. On August 17, 2006, the new BUHS gymnasium on the Narramore Avenue campus was dedicated. As pictured above, the first "Home of the Hawks" game was held on August 29, 2006, with a volleyball match against Flagstaff. Buck Faccio was again at the microphone as the "voice of the Hawks." (Then image courtesy of BUHS Library Archives.)

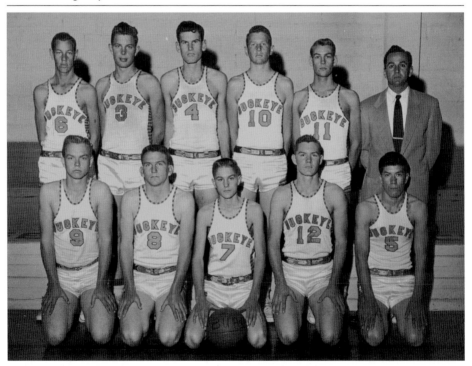

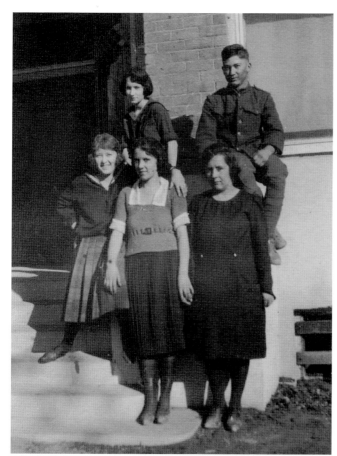

The first graduates of Buckeye High School were two sisters, Cordia and Ethel Campbell, in 1921. Five seniors in the Buckeye High School class of 1922 were Fred Bruner, Hulda Crouch, Amelia Kell, Nell Vickery, and Edna Wetzler. Fred Bruner's valedictory address on May 25, 1922, said, "May those who come after, be they many or few, keep faith with us who have gone before, love the school as we loved it, keep its records clean and white, and make a school which shall be far better than even our wildest dream." Below, Buckeye Union High School seniors at an August 28, 2009, pep assembly show "Hawk Pride." (Then image courtesy of Paul Bruner.)

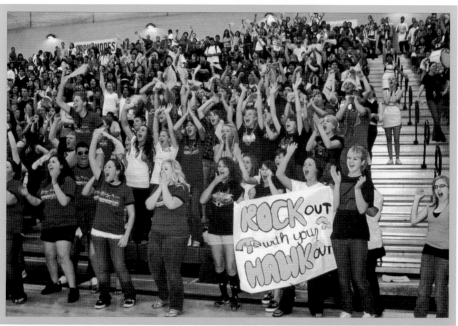

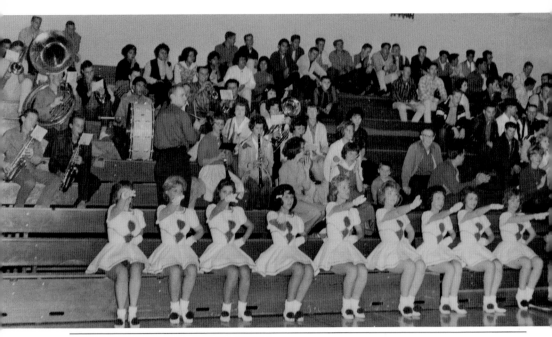

Spirit-filled pep rallies led by bands, cheerleaders, pom-pom squads, and spirit lines from 1962–1963 (pictured above) to 2009–2010 (shown below) are an important part of Buckeye Union High School (BUHS) history. The BUHS "Hats off to You" fight song provides much enthusiasm for the students. (Then image courtesy of BUHS Library Archives.)

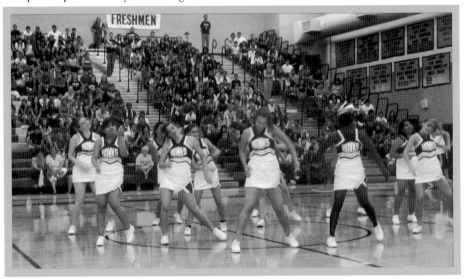

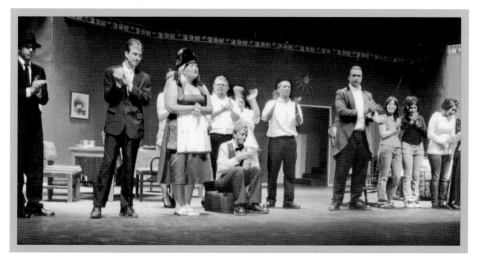

The senior class play cast presented *Those Webster's* on December 12, 1947, in the 1930-built auditorium. The play was directed by Audre Chapman. Among those posing below for yearbook coverage are Charles Green, Teresa Mulville, Marion Brisco, Wealthy Higgins, Barbara Lake, Dan Kauffroath, Henry Estrada, Beverly Wootton, Bill Parks, Pauline Ganley, Melvin Brown, and Johnnie Dew. Sixty-one years later (December 4–6, 2008), the 600-seat performing arts center played host to its first play, *You Can't Take it With You*, directed by Phillip Horne. Drama club members performing were Jayne Dunklin, Emily Lykins, Vanessa Marquez, Sean Hunt, Donovan Napolitano, Douglas Shaw II, Mackenzie Bair, Tyler Morlan, Gina Vazquez, Russell Card, Logan Stowers, Danny Quintero, Heather Scully, Ahren Bonnell, Elissa Mendez, Travis Bohanan, and Margo Brookover. (Then image courtesy of BUHS Library Archives.)

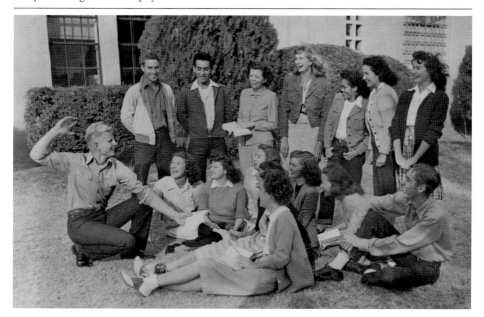

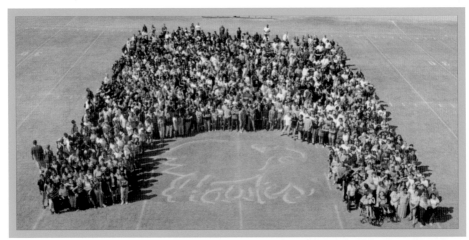

Pictured at right, the Buckeye High School student body stood on the roof of their school around 1925. The high school was located at the Sixth Street site of the present-day Buckeye Elementary School. Pictured above, 72 years later, students stand on the Buckeye Union High School (BUHS) football field for a *Falcon* yearbook photograph in 1999. Current 2009–2010 BUHS enrollment is approximately 1,550. (Then image courtesy of BUHS Library Archives.)

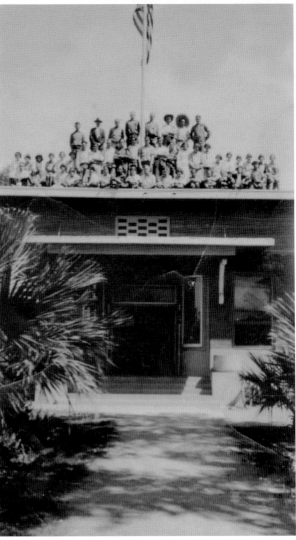

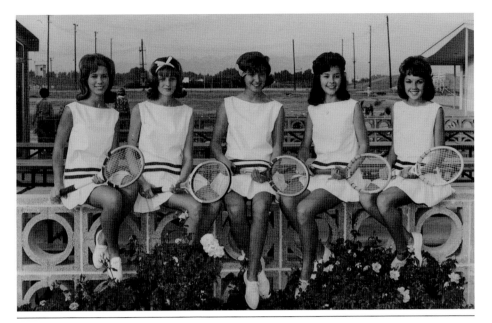

Above, a BUHS freshman tennis team, coached by Verlyne Meck in 1964, pose on the block fence that surrounded Hawks Haven. Pictured from left to right are Susan Couch, Leslie Butler, Ellen Hardesty, Sheri Stocks, and Karen Williams. At the 2009 Old Settlers Reunion (shown below), "young" team members met their "old" coach. From left to right are coach Meck, Karen (Williams) Goins, Ellen (Hardesty) Bolen, and Susan (Couch) Cox. These girls, along with many of Meck's other physical education students, remember her exercise motto, "We must!" (Then image courtesy of BUHS Library Archives.)

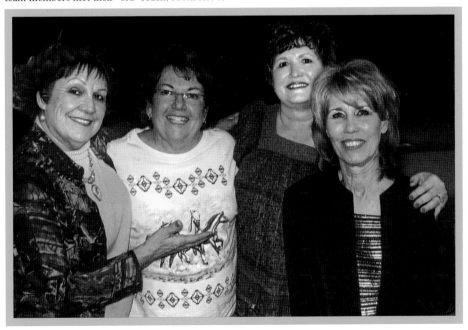

Libraries at BUHS have seen many changes. Until 1975, the library was located in the A-Wing study hall. Chester D. McNabb Library was dedicated in May 1975 with Marea Wood as the librarian. Wood retired in 1985, and Verlyne Meck and clerk Karen Hayden became the library staff. During their tenure, an online catalog and computers were added in 1991. On January 4, 2004, students entered the new campus and library on Narramore Avenue. When Meck and Hayden retired in 2006, Anna Jimenez and clerk Sherry Thomas took over the Dewey Decimal System with many technological advances. In 2007, the media center was named the BUHS Verlyne Meck Library. Students like Donovan Napolitano, Tommy Langendorf, Anthony Gonzales, and Santiago Sandoval (pictured below) savor the new setting. (Then image courtesy of BUHS Library Archives.)

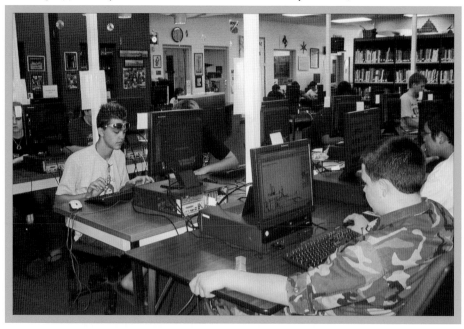

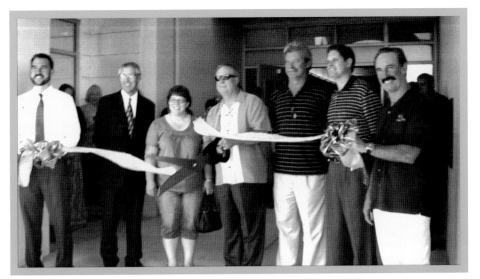

The 120-year-old Buckeye Elementary School District is experiencing phenomenal growth. From a small wood schoolhouse in 1889, to a 1915 brick quad building, the district now has six elementary schools: Buckeye, led by principal Lorrese Roer; Bales, led by principal Fred Lugo; Sundance, led by principal Tracy Casey; West Park, led by principal Ruben Ruiz; Jasinski, led by principal Montessa Banning; and Inca, led by principal Corey Christians. In July 2009, a new district office, named Michael W. Melton District Office Complex at 25555 West Durango Street, was opened. The August 6, 2009, ribbon cutters were (from left to right) Bill Resinas (chamber of commerce), Al Steen (district superintendant), Amy Lovitt (board member), Mike Melton (honoree), Richard Hopkins (board president), Scott Drew (CORE Construction), and Jay Broadbent (chamber of commerce). (Then image courtesy of Buckeye Valley Museum.)

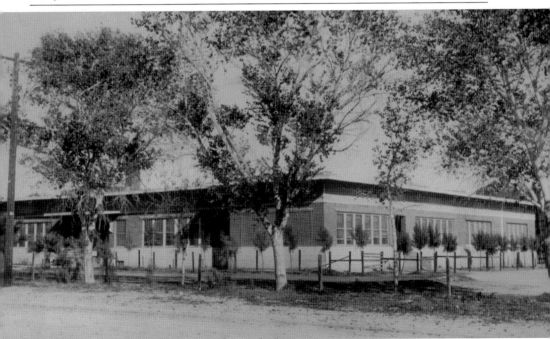

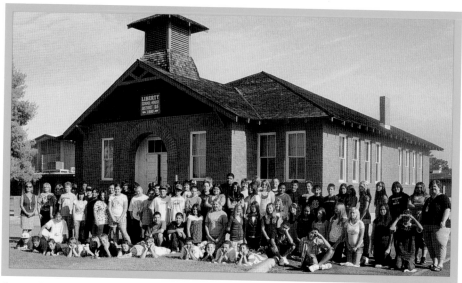

"Remembering Our Past and Building Our Future" was Liberty Elementary School's Centennial theme. At the school's 100th anniversary, the class of 2009 (shown above) is posed to mimic the entire student enrollment of 1914 (pictured below). Located at 19818 West Highway 85, the district began in 1908 with the original school building, constructed in 1910. District superintendent Dr. Andy Rogers and Liberty principal Nancy Bogart were excited by the Centennial mural painted by Ed Buonvecchio, which was unveiled at the 2009 promotion ceremony. Current district schools are Liberty, Rainbow Valley, Estrella Mountain, Freedom, and Westar. (Then image courtesy of Esther Woody Walls; now image courtesy of Janene Van Leeuwen.)

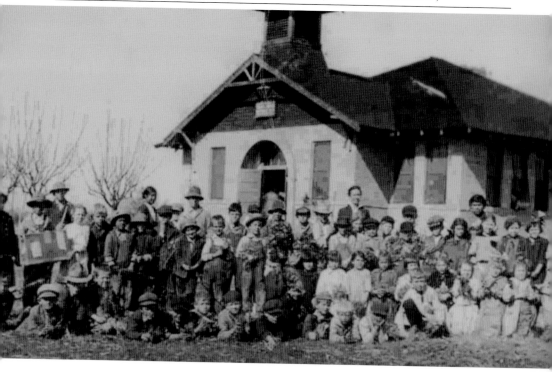

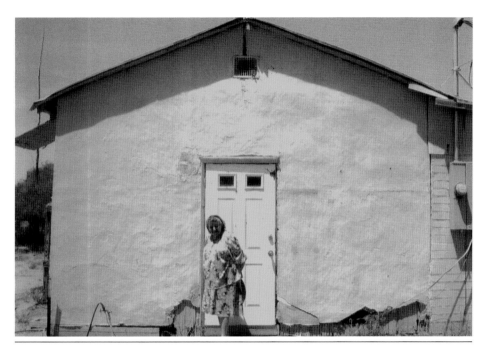

Underwood School (County Accommodation School) in Rainbow Valley was a one-room, wooden building for grades one through eight begun in 1932. Students were Swaim, Williams, Coats, Huffene, Butler, Stowers, Rawson, Persley, and Witt, and their teacher was Fay Bynum. The building was moved to the Swaim property in 1939 and permanently closed in 1955 due to annexation into the Liberty Elementary School District. Above, Vera (Swaim) Holloway stands by the Underwood School building, located on her property in Rainbow Valley. The new Rainbow Valley School opened in 2001, located on Narramore Road just east of Tuthill Road, with principal Pam Slade. (Then image courtesy of Vera [Swaim] Holloway.)

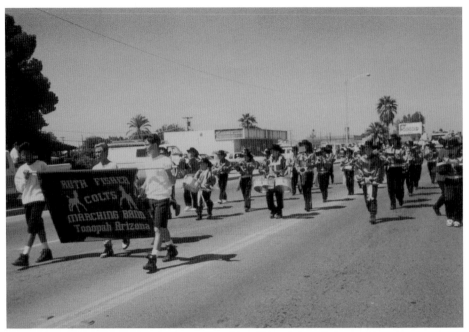

Ruth Fisher Elementary School was originally named Winter's Well School around 1929. In 1941, Ruth Fisher became a teacher at Winter's Well School. In 1964, local residents honored Fisher by changing the name to Ruth Fisher Elementary School. The Colts opened a new school campus in 1983, with a capacity for 550 students. Shown above, students participated in a 1994 Pioneer Days Parade. School facilities named after former principals include the football field for Ed Sanders in 1997 and the gymnasium (Mr. J's Gym) for Ruben Jimenez in 2009. The district is now known as Saddle Mountain Unified School District No. 90 and is led by Dr. Mark Joraanstad. It is composed of one high school, Tonopah Valley High School, with principal Edgar Garcia; and three elementary schools: Ruth Fisher, led by principal Dr. Deborah Garza-Chavez; Winter's Well, led by principal James Keith; and Tartesso, led by principal Carolyn Hardison. (Then image courtesy of Linda [Sanders] Hardison.)

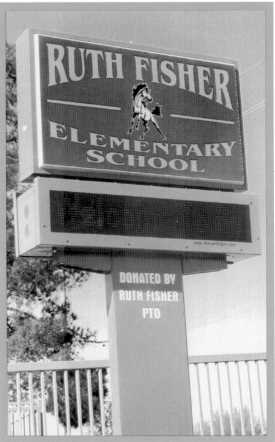

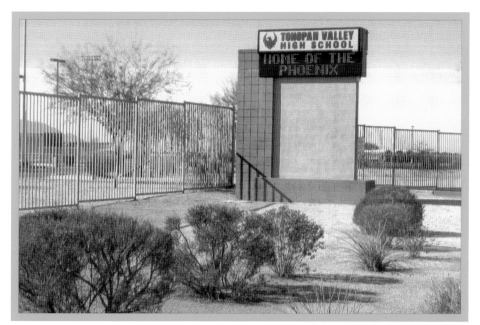

Tonopah was the only place to get water in the early 1900s, so people started to form a community there. According to homesteader residents of the area, *Tonopah* is an Native American word meaning "hot water under the bush." In 1932, in Harquahala Valley, a new school was built, named Range 2N 8W Accommodation School but commonly called Crawford's School. Family names represented in the school were Reid, Crawford, Parker, Pirtle, and Wright, with teacher Mason W. Davis. School was held for two and a half years with at least eight students. The school bell is a car wheel disc hanging from a board, which was hit with a piece of iron. In 2005, Saddle Mountain Unified School District No. 90 celebrated the opening of its first high school, Tonopah Valley High School (Home of the Phoenix). Previously, high school students traveled many miles to attend Buckeye Union High School or Wickenburg High School. (Then image courtesy of Hazel [Reid] Richardson.)

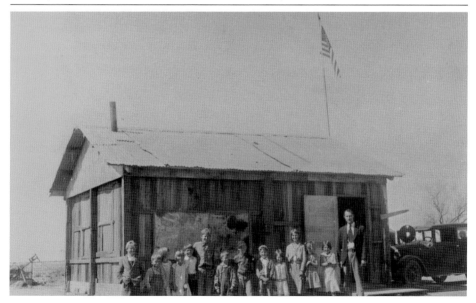

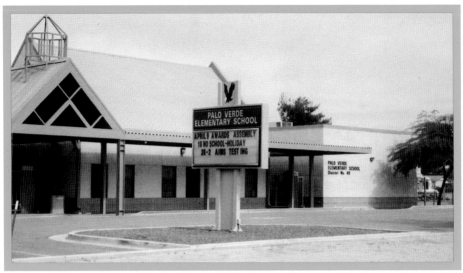

Palo Verde Elementary School District No. 49 began in 1896 as a result of deannexation from Arlington School District No. 47. It began with a building on the southeast corner of Palo Verde Road and Old Highway 80. Property was purchased on the northwest corner of Palo Verde Road and Highway 80, and a new school was built and ready for 50 students in September 1910. A bell in the tower called students to school and relayed important news such as the ending of World War I, a bank robbery in Buckeye, and fires in the community. Sitting at the same location is a new school campus, built in 1993. Principal Robin Berry serves the school well. To remember Palo Verde School is to remember former principal Louis F. Joslin and his wife, Mary, who together began a 35-year career in 1942. (Then image courtesy of Buckeye Valley Museum.)

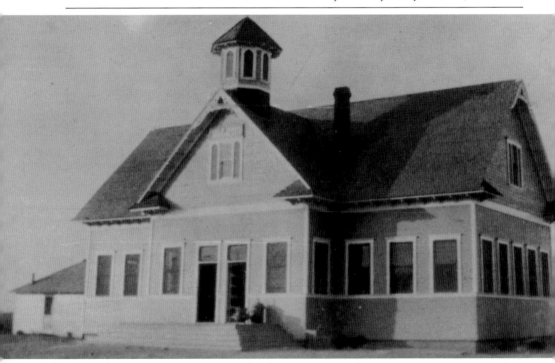

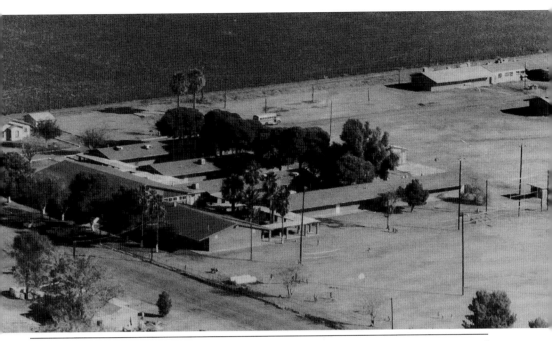

Residents of Arlington have actively supported elementary education for 115 years. That education began in a one-room schoolhouse in 1894, which is part of the stolen schoolhouse legend. Another wooden one-room schoolhouse was built around 1910, followed by a gray cement, two-room brick building around 1930. The fourth school, pictured above, was built around 1948. Due to flooding, the redbrick campus on Arlington Road closed its doors in December 2003. A monument now recognizes this historic site. Arlington School District No. 47 continues today at a state-of-the-art facility located near Dobbins Road and 355th Avenue. It was built in 2004, and Chad Turner serves as superintendent/principal. As a side note: In 1962, Harquahala Valley School, which began in 1929, joined the Arlington School District No. 47. The Harquahala Valley School no longer exists. (Then image courtesy of Dianna [Richardson] Workman.)

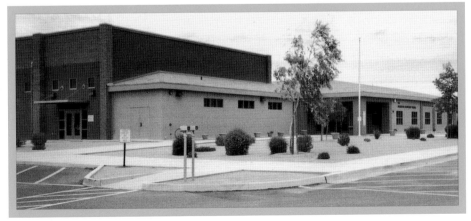

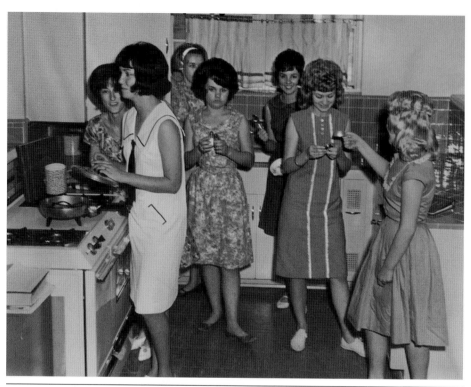

Names of high school classes have changed. What previously were home economics classes are now known as culinary arts. In 1943, BUHS girls had home economics classes in the A-Wing. In 1964, home economics classes were in the B-Wing, and only girls were enrolled. In one of four kitchens, (from left to right) Elaine Hindman, Lyn Davis, Donna Williams, Fonda Buckner, Terry Martin, Susan Youngker, and Pam Lancey measured ingredients and cooked. On September 25, 2009, culinary arts students at BUHS created salsa and chicken quesadillas. Teacher Lily You gave instructions in the modern-day kitchen classroom. (Then image courtesy of BUHS Library Archives.)

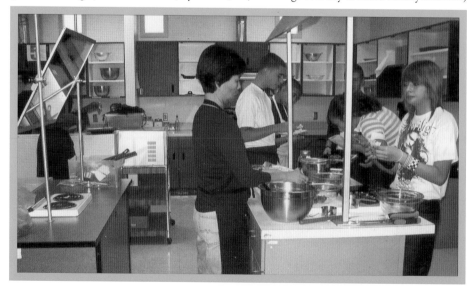

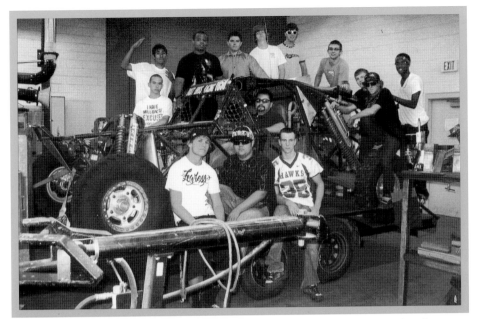

Technology has always been important at BUHS. Pictured below in 1967, instructor Hank Newberry's industrial arts students made wood award plaques for the Pioneer Days Parade. It was noted that the electric drill is still in the district, now at Youngker High School. Teaching welding for 14 years has been a passion for Ali Jimenez (pictured above in the driver's seat). The advanced welding class is proud of an off-road race car (shown above). Jimenez said, "The welding and fabrication is a never ending five-year project." (Then image courtesy of Buckeye Valley Museum.)

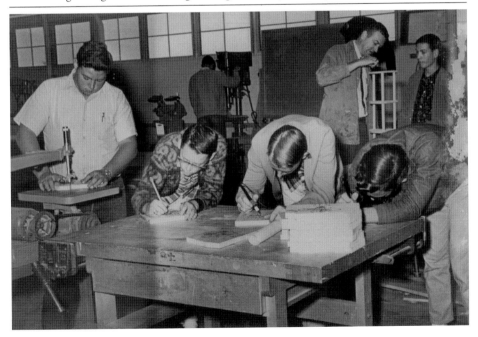

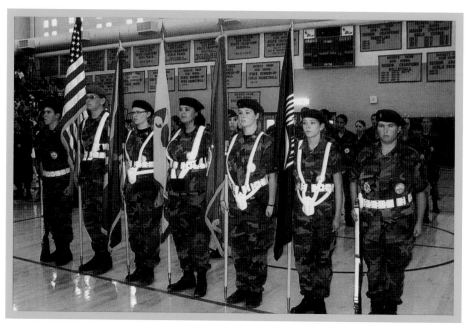

Through the years, outstanding students have given exemplary service to their school. A patrol squad from BES in 1951 helped students safely cross Monroe Avenue (pictured below). At the first 2009–2010 BUHS Hawks pep assembly, the Air Force Junior Reserve Officer Training Corp (JROTC) presented the colors (shown above). The program is in its fourth year and is led by Lt. Col. Tom McClain USAF (ret). Cadets are (from left to right) Teddy Potter, Matthew Todd, Martika Long, Victoria Heyl, Jennifer Shearer, Alyssa Perez-Snyder, and Sharamie Russell. (Then image courtesy of Bob Bonnes.)

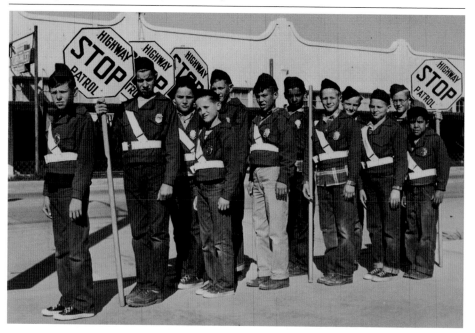

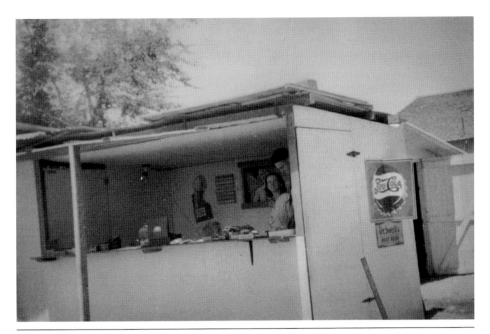

Lunchtime for high school students means food and break time. Before the days of a modern cafeteria, BUHS students ate in various venues. In 1946, Price and Clover Curd operated a sandwich shop in their yard at Ninth Street and Edison Avenue. Martha (McElhannon) Gayle remembers a great tuna sandwich, a bag of Frito's or potato chips, and a pop for 25¢. Then, in 1963, Hawks Haven was on campus and provided for the lunch bunch until 2003. It had replaced a wooden snack bar, with a drop-down service window, located just west of the new "Haven." When students entered the new campus on January 5, 2004, a new Hawks Haven cafeteria became the hub for lunch. As a side note: Students had the option to leave campus for lunchtime until the 2009–2010 school year, at which time BUHS became a closed campus. (Then image courtesy of Martha [McElhannon] Gayle.)

A brand new tradition was added in 1943 to the annual BUHS homecoming dance—the crowning of a homecoming king and queen. The student body determined the winners by voting. The votes cost 1¢ each, and a student could vote as often as the pocketbook allowed. At the dance, the secret winners were revealed, and principal Herschel Hooper crowned queen Betty Jean Rhodes and king Ray Carr. The queen's attendants were Betty Cooper, Dorothy Killman, and Royleen "Chickie" Balmes. Betty (Rhodes) Martin in 2009 still reigns as Buckeye's first homecoming queen. In 1964–1965, the royalty was chosen by popular vote. Candidates were (pictured above, from left to right) Jeri Robinson, Leon Hardison, Renee Compton, Tom Schweikart, queen Susan Youngker, and king Wayne Clark. Shown below, royalty in 2009–2010 were Michael Baca and Lara Benbow. Now when chosen by the student body, it does not cost 1¢ a vote!

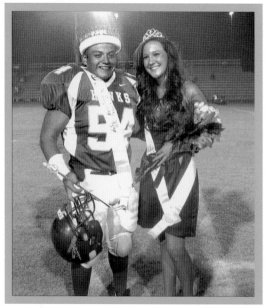

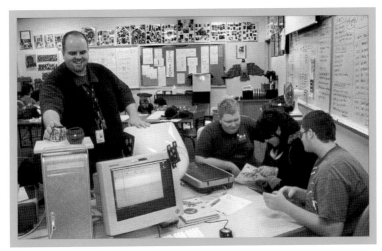

School yearbooks preserve the history and memories for each year they are published. Beginning in 1925, the first Buckeye High School yearbook was *El Ocotillo*. It stated, "We hope the future makers of *El Ocotillo* [later *The Buckeye* and *The Falcon*] will profit by our mistakes and make it larger and better each succeeding year." Shown below, staff members were, from left to right, (first row) Eugene Leister, Lillian Trimble, Merle Parkman, Edith Schweikart, Helen Kincaid, and Daniel Kincaid; (second row) editor in chief Norma Brown, Donnie Keeling, Irma Brown, and Dessie Hardesty; (third row) Carroll Parkman, Velma Couch, and Harry Long. Now *The Falcon* yearbook staff continues to preserve the BUHS story using computers and digital cameras instead of the paper cutters and rubber cement. Pictured above, staff members work on the 85th-anniversary 2010 edition. The coeditors were Ethan Newport and Lauren Marquez. First-year advisor Steve Truog follows on the *Falcon* wings of Ryan Witting (2005–2009), Verlyne Meck (1986–2005), and Eddie Amabisca (1961–1986). (Then image courtesy of BUHS Library Archives; now image courtesy of Ethan Newport.)

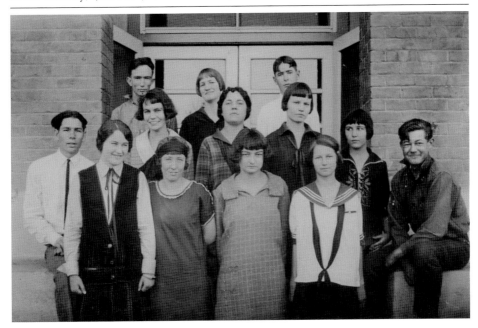

A "B" on the A-Wing chimney means Buckeye. Below, in a photograph taken in 1935 by Mildred (Shepard) Meck, her friends parked a car on campus. Today the same "B" remains, standing guard over the old A-Wing of the original Buckeye Union High School, located at 902 Eason Avenue. The A-Wing now belongs to the Town of Buckeye, and on December 30, 2009, it was entered into the National Register of Historic Places. (Then image courtesy of BUHS Library Archives.)

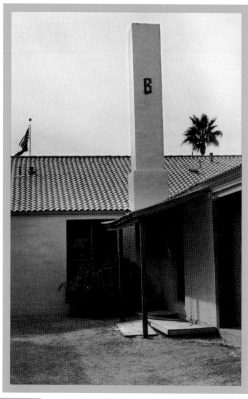

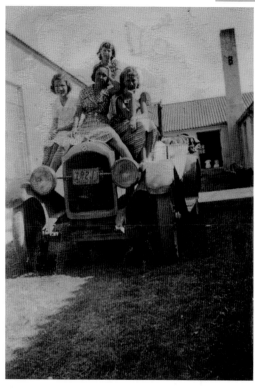

CHAPTER 5

FROM THEN TO NOW

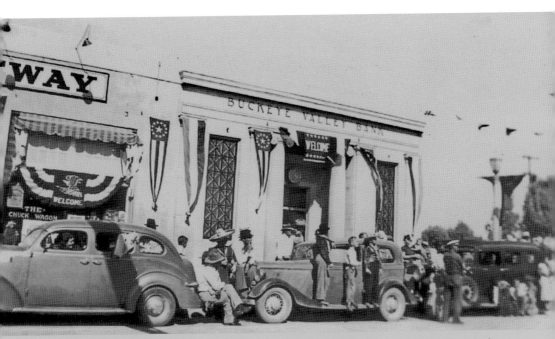

Helzapopin, formerly Dias Viejos in the 1930s, was a combined carnival, circus, parade, and county fair. Those events provided four of the dizziest and maddest days of fun known anywhere. Former resident Frank Zellner reminisced about the 1950s. "We were so lucky to have leaders in our little community who cared and made life so wonderful back in our day. I recall how excited I used to get over the rodeo, the Halloween carnival, the staged shows at the high school, and the wonderful programs the American Legion sponsored for our youth. I could go down the list and name them one by one. It was people who took the time to make the quality of life around them a little better. I have always felt so blessed to have grown up in such a community." (Then image courtesy of Dianna [Richardson] Workman.)

"An old desert road, started by a wagon train, worn by homesteaders, automobiles, and packed by wood hauler trucks" is Bill Meck's description of scenery around 1935. Change is not a passing "thing," instead it is a continuous process. The road to California is now Interstate 10, instead of U.S. Highway 80 through downtown Buckeye. A side note: In July 1973, then-mayor Jackie Meck went to Phoenix and reported that 150 people responded to a poll that the interstate be continued from Tonopah through the Buckeye Valley as soon as possible. (Then image courtesy of Bill Meck collection.)

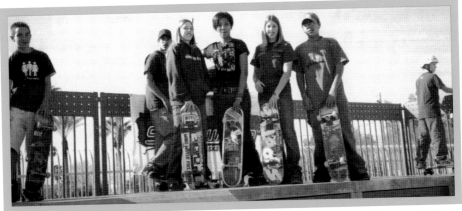

Extreme sports are exciting games for kids. In the late 1940s, on the Howard Henry family farm, Verlyne climbed a haystack when it was playtime with her little brother Charles, and the family dogs Duke and Queenie. On February 26, 2005, the Buckeye Skate Park on Ninth Street and Monroe Avenue held its grand opening. Among the skaters that day were Marissa Maki, Debbie Ochoa, Mariah Maki, Joel McConnell, and Justin Ott.

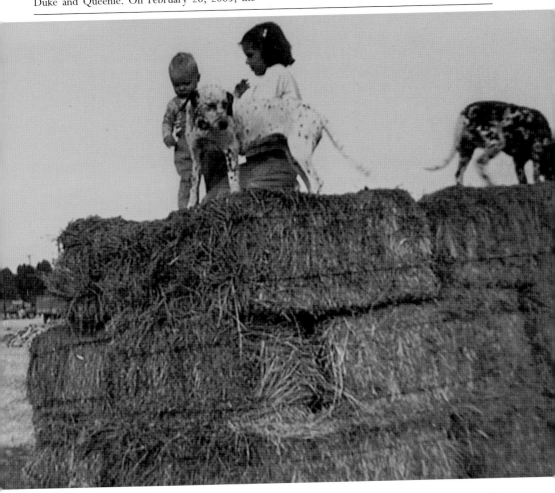

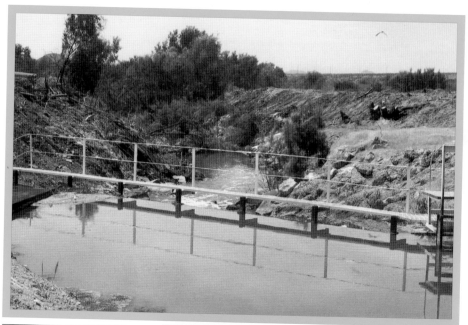

Since 1885, the Buckeye Canal has been providing water to Buckeye Valley farmlands. The head gate (shown at right), located at the junction of the Agua Fria and Gila Rivers, empties into the Hassayampa River 31 miles to the west. Canal founder Malie Monroe Jackson's dream of bringing water to the parched land has become a reality.

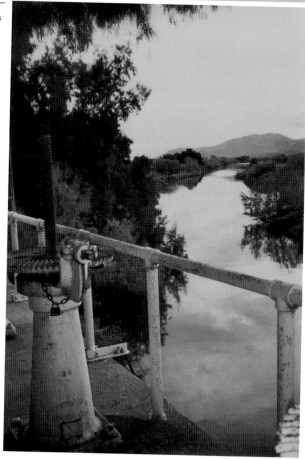

In just seven months, from May to December 2009, the scene on the east side of Watson Road, south of I-10, changed dramatically. A Circle K Convenience Store and McDonald's Restaurant, owned by Don Mellon, in the Watson Marketplace provided another service for the Buckeye Valley. The McDonald's ribbon-cutting ceremony was held on December 18, 2009.

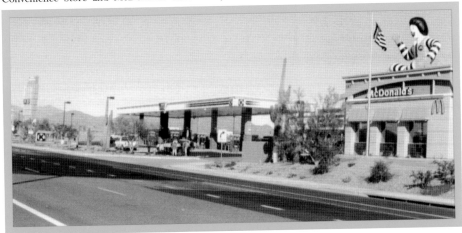

Cacti in the Buckeye Valley continue to tell a story. Two young men, Sam Richardson (left) and Dick Kreager (right), in the Arlington Valley, were upheld on the arms of a giant saguaro. From a 1935 scene to a 2009 scene near I-10 and Watson Road, cacti remind us that we are friends supporting each other, then and now, for whatever the future holds. (Then image courtesy of Hugh Richardson.)

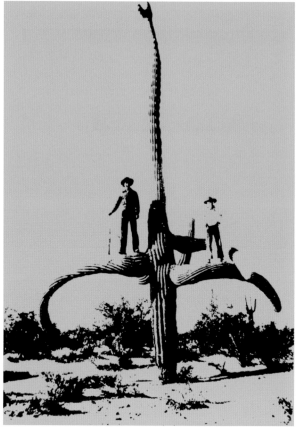

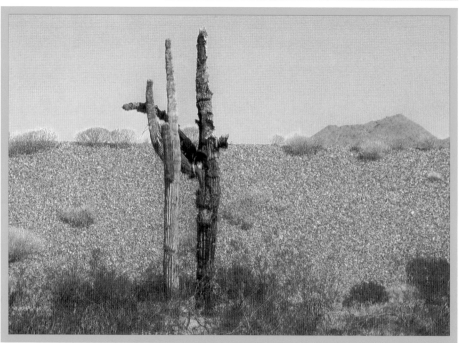

Then and now farmers reminisce, "You been farming long?" Closing thoughts about then and now bring to mind a poem by James D. Grosbach, a BUHS English teacher from 1964 to 1996. Written in 2002, the poem, titled "The Gift," states: "When God began to plan His garden, He perhaps pondered which gifts He would give to each creation. To the flowers, He gave scent and color, to the birds, the gift of flight and sure direction, to the cattle, the gift of usefulness to humankind, and to the insects the sounds of summer hum and buzz. Then He gave the lion its strength and the gazelle its blurring speed and the great whales their mysterious mastery of the open seas. He paused, then, at the human being, who could not fly, could not flee with blurring speed and could not live in the dark deep seas. And smiled, and gave us the wonder, the beauty, the strength and the power of Memory."

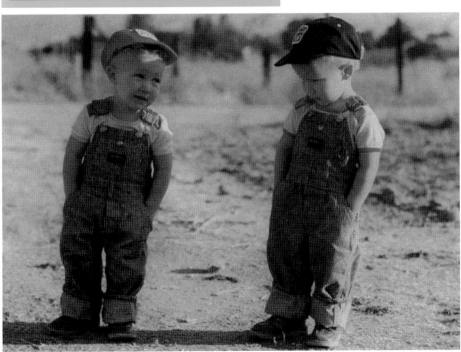

www.arcadiapublishing.com

Discover books about the town where you grew up, the cities where your friends and families live, the town where your parents met, or even that retirement spot you've been dreaming about. Our Web site provides history lovers with exclusive deals, advanced notification about new titles, e-mail alerts of author events, and much more.

Find Your Place in History.